George Grosz

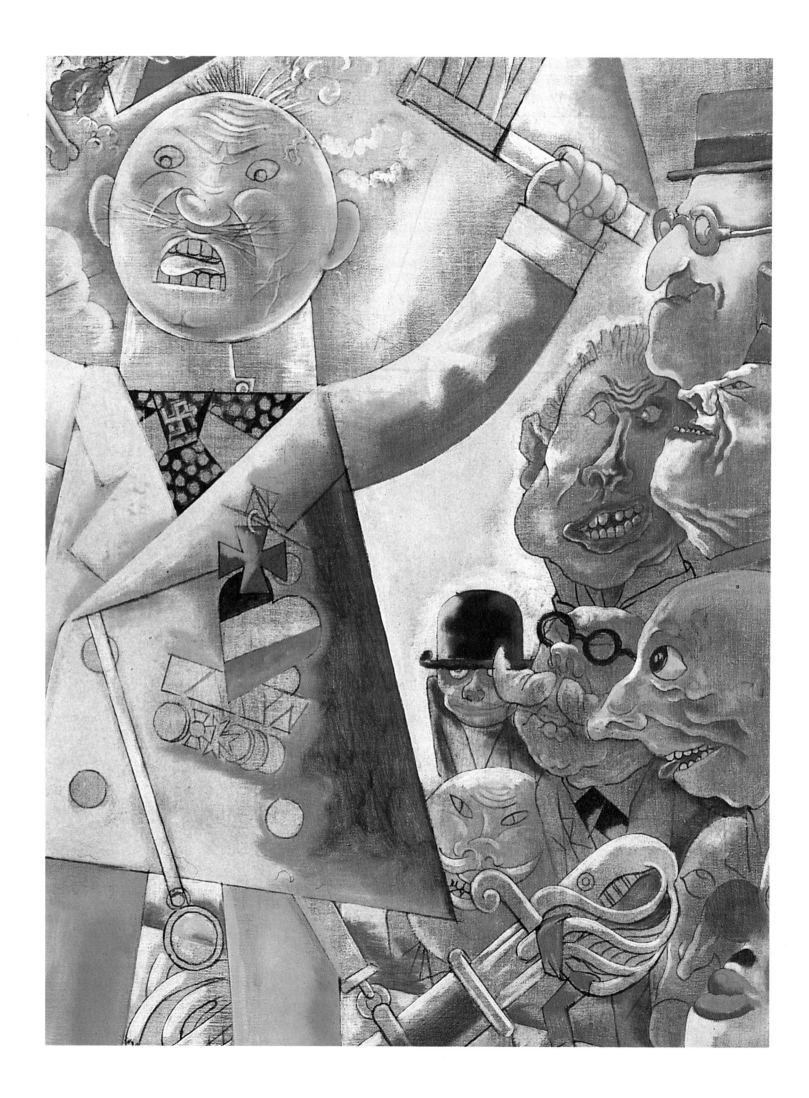

Ivo Kranzfelder

GEORGE GROSZ
1893–1959

Benedikt Taschen

FRONT COVER:
The Pillars of Society (detail), 1926
Oil on canvas, 200 x 108 cm
Berlin, Staatliche Museen zu Berlin – Preußischer
Kulturbesitz, Nationalgalerie

ILLUSTRATION PAGE 1:
Pastoral (detail), 1921
No. 77 in "Ecce Homo"

ILLUSTRATION PAGE 2:
The Agitator (detail), 1928
Oil on canvas, 108 x 81 cm
Amsterdam, Stedelijk Museum

BACK COVER:
Grosz with *The Pillars of Society*, 1926
Photo: Princeton (NJ), Copyright Estate of George Grosz

**This book was printed on 100 % chlorine-free bleached
paper in accordance with the TCF standard.**

© 1994 Benedikt Taschen Verlag GmbH
Hohenzollernring 53, D–50672 Köln
Edited by Rolf Taschen, Cologne
English translation: Michael Hulse, Cologne
Cover design: Angelika Muthesius, Cologne
Typesetting: Utesch Satztechnik GmbH, Hamburg
Printed by Druckhaus Cramer GmbH, Greven

Printed in Germany
ISBN 3–8228–9312–9
GB

Contents

6
"Alone with my Doppelgängers"

8
Pulp Magazines and Plaster Casts

14
"Oh that City Feeling"

26
Revolution and Dada

40
Weapons and Straws

52
Critical Realism and Disillusionment

76
Dream and Reality

92
George Grosz 1893–1959: A Chronology

94
Illustrations

"Alone with my Doppelgängers"

Grosz in his Berlin studio, 1921
The usual image of Grosz is of a politically committed painter and cartoonist whose critique of society was biting. He himself felt he was far more versatile.

The career of George Grosz is the perfect example of an artist's life tied inseparably to the historical, social and political movements of the age and lived in response to them. Grosz was born on 26 July 1893 in Berlin, three years after Chancellor Bismarck's dismissal by Kaiser Wilhelm II. Growing up in the Kaiser's empire, Grosz volunteered on the outbreak of war in 1914 but in 1915 was discharged, unfit for service; in 1917 he was called up again, only to be discharged for good soon after. Following the revolution in Russia, an artists' association, the "November Group" was established in Berlin in 1918, and Grosz joined. At the end of that year he became a member of the Communist Party. In 1919, with the publisher Wieland Herzfelde (of Malik Publishing), he started a magazine, "Die Pleite" (roughly: bankruptcy or disaster), and collaborated with Franz Jung on "Jedermann sein eigener Fußball" (Everybody his own football) and with John Hoexter and Carl Einstein on "Der blutige Ernst" (The bloody seriousness). His drawings, tartly critical of society, appeared in various Malik publications; Grosz also produced portfolios and books. In 1921 he was prosecuted for defamation of the Reichswehr (army); in 1924 for offences against public morality; in 1928 for blasphemy. In 1924 he became chairman of the artists' association "Rote Gruppe" (Red Group); until 1927 he was a regular contributor to "Der Knüppel" (The Stick), a Communist satirical weekly. In 1927 he supplied drawings to assist Erwin Piscator in his stage production of "The Good Soldier Schwejk". In 1928 he was co-founder of the "Association Revolutionärer Bildender Künstler Deutschlands" (German Association of Revolutionary Artists). In 1932, invited to lecture to the Arts Student League in New York, Grosz visited the USA, and the following year emigrated there together with his wife.

A new chapter now began in his life. It has often been noted that in his last publications in Germany, such as "Der Spießer-Spiegel" (A Mirror for Philistines, 1925) or "Über alles die Liebe" (Love above all, 1930), his satire on bourgeois life was milder than his earlier barbed political attacks. In the American years, Grosz retreated somewhat from his former positions; his analyses of the age took on a generalized apocalyptic tone, and, apparently becoming resigned, he turned increasingly to landscape painting.

His resignation was at heart cynicism, as is made clear by a passage in his autobiography, "Ein kleines Ja und ein großes Nein" (A Small Yes and a Big No; YN hereafter), first published in Germany in 1955. Grosz is describing the attempt to fit in perfectly with his new home: "My motto was now to give offence to none and be pleasing to all. Assimilation is straightforward once one overcomes the greatly overvalued superstition concerning character. To have character generally means that one is distinctly inflexible, not necessarily for reasons of age. Anyone who plans to get ahead and make money would do well to have no character at all. The second rule for fitting in is to think everything beautiful! Everything – that is to say, including

things that are not beautiful in reality. […] One day one finds that everything really is beautiful – and lo and behold, within a few years of ceaseless lying the lie will have become the truth…" This strikingly anticipates Andy Warhol's slogan, "All is pretty", which the pop artist was to take as the hallmark of the American way of life and the cornerstone of his own art.

In the late 20s and early 30s, and in America, Grosz's subject matter and style underwent a change. In the context of the period, and as part of his own development, the change was consistent. Philosopher Günther Anders has observed of Grosz's post-1930 art: "No one was more aware than Grosz himself of how absurd it would have been to persist in lambasting targets that were already figures of the past or forgotten ghosts of yesteryear."

Two statements Grosz made early in his career highlight the continuity in his thought. In 1917 he co-founded the Berlin wing of the Dada movement. Every member was assigned a function, Grosz's being designated as "propagandada". On his calling card, under his job description, was printed the question, "What shall I think tomorrow?"

And in 1920/21, in the periodical "Der Gegner" (The Opponent), Grosz published a piece titled "Statt einer Biographie" (Instead of a Biography), in which he speculated: "How is the artist to climb the bourgeois social ladder these days? – – – by trickery – – –. Generally he starts out in proletarian circumstances, in a filthy studio, but with an admirable, unconscious talent for conformity he sets out to make it to the top, and soon finds a big shot who makes him, that is, smoothes his passage onto the capital market."

This early position was combative and profoundly moral, and bespoke real commitment; subsequently, in America if not before, he grasped that direct political action had become anachronistic, and changed his tactics to subversion in the guise of seeming conformity, which was to be Warhol's principle.

Two points are worth stressing before we turn to Grosz's work and, where relevant, his life and the broader historical context. The first is that we are fortunate in having relatively good source material at our disposal – not only the autobiography referred to above, but also a published selection from his copious correspondence, a volume of his poems (published in 1986), and numerous writings on current affairs and art. It is advisable to approach this material with caution; Grosz was a shapeshifter, continually trying out new roles, even in his letters. In a letter written in late September 1915 to fellow-student Robert Bell, he described the role-playing that was to remain a feature of his character throughout his life: "I am endlessly lonely, that is to say, I am alone with my doppelgängers, phantomatic figures in whom I make particular dreams, ideas or penchants etc. real. I drag up 3 distinct personalities from my inner imaginative world, and I myself believe in the roles played by these pseudonyms. In time, three clearly defined types have come into being. 1. Grosz. 2. Count Ehrenfried, the nonchalant aristocrat with manicured fingernails, intent on cultivating himself, in a word: the stylish aristocratic individualist. 3. Dr. William King Thomas, more of an American-cum-practical, materialistic, compensatory figure in the Groszian maternal self."

The second consideration is Grosz's loathing of the masses, his political commitment notwithstanding. He had read Gustave Le Bon's 1895 "Mass Psychology" and trusted to his own "observation, which has always confirmed that the human masses are a pitiful mob, an easily influenced herd of cattle that like nothing better than to choose their own butchers."

TOP:
Grosz's puppet *Conservative Gentleman,* 1919
Detail from p. 34 (bottom)

BOTTOM:
Grosz as Clown and Revue Girl, 1958
Detail from p. 91 (right)

Pulp Magazines and Plaster Casts

Georg Ehrenfried Groß (to give him his full name) grew up in Berlin and in the town of Stolp in provincial Pomerania. His father, an innkeeper, died when the boy was six; his mother was a caterer to the Marshal Blücher Hussars officers' mess. From 1902 Georg went to Stolp secondary school. He was an avid reader of the "Leipziger Illustrierte" paper, with its "marvellous drawings of the battlefields of the day" (YN p. 9); "Das Neue Universum" (The New Universe), a periodical devoted to the latest scientific developments; James Fenimore Cooper's Leatherstocking tales; and, of course, Karl May, the German author of adventure stories, whom (Grosz recalled in his autobiography) he visited together with a friend. He devised games based on Cooper and May, and later drawings. A cousin put him in touch with a painter and decorator called Grot, who introduced the young Grosz to Art Nouveau, and meanwhile he was acquiring his own preferences among artists. He was particularly fond of Eduard Grützner, a prolific painter of monks drinking toasts in wine cellars, scenes of a kind that are still often hung in rooms furnished in traditional German style. Grosz also liked history and battle scenes, and the panoramic horror pictures shown at fairgrounds – as we might expect of a youngster who read pulp shockers at 10 pfennig a go, or 20 if the stories were American adventures involving Buffalo Bill or Nick Carter. "Many of these superb stories were set in America, a romantic pre-War America. I don't know if what I read in my youth accounts for the fascination with America that has stayed with me to this day." (YN p. 26) Certainly these sources (and the Barnum and Bailey circus, which still featured a freak show in those days) were at the root of Grosz's relish for the sensational, for subjects such as crime, sex murder and deformed facial features: "This feast of the abnormal made an indelible impression on me." (YN p. 27)

Grosz copied anything and everything – Busch, Grützner, history paintings, broadsheet illustrations – and drew what he saw about him. In 1908, shortly before sitting his school-leaving exams, Grosz was expelled, one consequence of which was that he had to complete two years of military service (rather than only one). He found school discipline unbearable, and described his teachers in terms that anticipate the characters he drew later in life: "Many of my teachers were oddballs, bizarre drillmaster types with pot bellies, weird baggy trousers and collars of an impossible fit." (YN pp. 42–3) Grosz was expelled because when a trainee teacher boxed his ears he returned the blow; and the refusal to conform, apparent here for the first time,

Illustration for "Ulk", supplement of the "Berliner Tageblatt", 1910
His first published drawing, this shows Grosz still under the decorative influence of Art Nouveau and the caricaturist tradition of "Simplicissimus" magazine.

Going to Work, about 1912
"I wanted to get ahead – that was my simple philosophy of life, one which I doubtless shared with all artists when they begin. That I was completely unpolitical can be taken for granted." Thus Grosz in his autobiography.

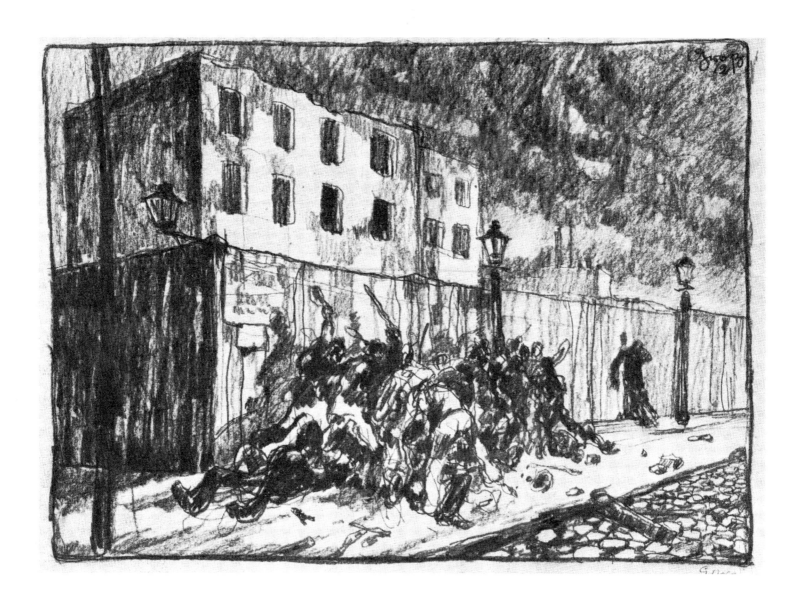

Street Fight, 1912

Karl Hubbuch, who studied with Grosz at the College of Arts and Crafts, recalled: "At the time the only striking thing about Grosz was his self-confidence (not arrogance). His modern clothes and American style got him noticed. (…) He also organized our life class, which we paid for ourselves."

was to be a basic component in Grosz's attitude throughout, as we shall see, even during the American years.

With the support of his former art teacher, Grosz managed to talk his mother into sending him to art college, and after passing the entrance exam he began his studies at the Royal Academy of Art in Dresden. His teachers were Richard Müller (who was to organize an exhibition of "degenerate art" in Dresden as early as 1933), Oskar Schindler and Robert Sterl. "Our training mainly consisted in making full-scale drawings of plaster casts." (YN p. 60)

Ernst Ludwig Kirchner, Erich Heckel and Karl Schmidt-Rottluff, members of the "Brücke" Expressionist group, were active in Dresden at the time, but Grosz knew nothing of their art. Later he was to turn against them: "Expressionist anarchy has to stop. Nowadays painters necessarily take to it since they are unenlightened and lack connection with working people."

When Grosz was at the Dresden Academy, though, there was as yet no sign of this politicization of art. He read Gustav Meyrink, Hanns Heinz

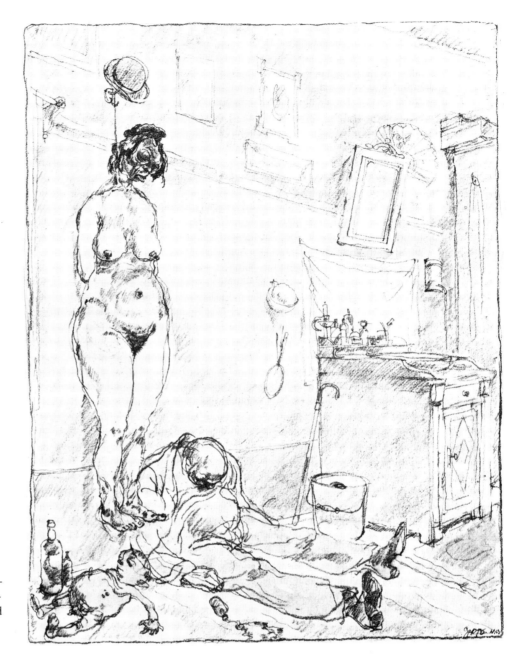

Evers and Maurice Renard, and prized the dandy Barbey d'Aurevilly:
"Many of these writers had a fruitful influence on my work, or at least, if I
may use the term, my philosophy of life." (YN p. 84) Even at the Academy,
Grosz liked to act the outsider and the dandy, and in this he was squarely in
line with one main view artists have taken of themselves since antiquity. An
autobiography written about the same time as Grosz's, that of Salvador Dalí,
gave a far more drastic account of this kind of pose.

For quite a time, Grosz, who had heard that cartoons were a good way to
earn money, had been trying to place drawings in humorous magazines. He
submitted drawings in the style of Bruno Paul or Emil Preetorius, caricatur-
ists for the famed periodical "Simplicissimus", to various publications, but
met only with rejection. Then on 4 February 1912, "Ulk", the weekly satiri-
cal supplement of the "Berliner Tageblatt", became the first to publish a
Grosz drawing (p. 9). Grosz reported that he promptly spent the fee on a pair
of American patent-leather shoes. The style of the drawing is in line with Art
Nouveau, and betrays little of Grosz's later style, though the interaction

Heinrich Maria Davringhausen:
The Sex Murderer, 1917
Davringhausen's treatment of sexual crime is more innocuous than Grosz's. The bloodshed is still to come, and in this way he avoids the gruesomeness of Grosz, Otto Dix or Rudolf Schlichter.

ILLUSTRATION PAGE 13:
John the Sex Murderer, 1918

among the characters – the two ample-bellied men contemptuously observing the promenading couple in the background – is more suggestive of what was to come.

In 1911 Grosz left the Dresden Academy – which purchased two of his drawings – and moved to Berlin, where in 1912 he joined the graphic art course at the College of Arts and Crafts. Emil Orlik, his tutor there, helped Grosz perfect his skills in rapid sketching, to capture the passing moment. The drawings Grosz did in 1912 and 1913 were mainly of fairground, circus and freak-show motifs, of crimes and orgies, and of erotic subjects. In his thematic concerns, perhaps, Grosz was arguably touching the mood of the times, on the eve of the First World War. It would be difficult to outdo the despair in *End of the Line* (p. 11), which shows a naked hanged woman in a working-class setting, and, on the floor beneath her, her dead child and husband. Grosz is invariably described as a satirist, a label he too often used of himself; but in this drawing and elsewhere in his early work we see the realist (as distinct from naturalist) in him. This strain was to remain. Grosz was an adept at suiting his style to his subject. What can often seem exaggeration in his drawings need be nothing of the kind, as we shall be seeing in due course.

In 1913 Grosz spent several months in Paris, where he practised five-minute sketches at Colarossi's studio – a technique he had already been practising himself. His sketchbooks show the perfect touch he now commanded. The next step was to paint in oils, and he began to do so before the outbreak of war. Grosz considered himself a self-taught artist for whom everything was rooted in graphic drawing: "I began painting from imagination, compositions much like my drawings, and would first do the drawing on the canvas in Indian ink before overpainting it in oils. The pictures were conceived on a line basis, inked-in rather than painted." (YN p. 100)

"Oh that City Feeling"

To Grosz in a 1914 drawing, the world – or at least the city, that constant subject of his art – was *Pandemonium* (p. 19). His style had undergone a radical change. Influenced by Expressionism and particularly Futurism, he was now using a complex tangle of lines to establish figures that were merely outlined, transparent as it were. The aim was to present events that were taking place simultaneously: murder and robbery, rape and lust, accidents, dogs making off with severed limbs or gnawing at murder victims. In the foreground, sinister characters armed with picks, knives and revolvers are striding out of the picture, bearing mayhem into the world – realism, this, not exaggeration. Grosz's sources of inspiration in pulp magazines had been joined by others in graffiti and children's drawings: "and so", as he later wrote, "I evolved a razor-sharp style which I placed at the service of the absolute rejection of humanity which then accompanied my observations."

Time and again, critics insist that the motivation of Grosz's art was hatred, or a misanthropy aesthetic in origin. Yet this aesthetic standpoint was ultimately moral in nature. And, as Grosz was often to stress (in his much reiterated contempt for "the masses" and thus for parties or associations of whatsoever description), it was a stance that touched only tangentially on organized political involvement.

In November 1914 Grosz volunteered, not because the war had prompted an excess of patriotic feeling in him but simply in order to preempt conscription and so perhaps avoid the worst that war had in store: fighting at the front. In 1915 he had an operation for sinusitis, and that May was discharged from the army as unfit for service.

Back in Berlin, Groß frequented the "Café des Westens", the meeting place of various writers and intellectuals. Among them were Theodor Däubler, who published an article on Grosz in the "Kunstblatt" in 1916, bringing him to the attention of a broader public; the poet Else Lasker-Schüler, who for a short time was married to Herwarth Walden, editor of the weekly "Der Sturm" (The Storm) and proprietor of a gallery that bore the same name; the writer Gustav Landauer, who after the War was to be one of the leaders of the Bavarian soviet republic of 1919, together with Kurt Eisner, Erich Mühsam, Ernst Teller and others; Richard Huelsenbeck, a subsequent co-founder of Berlin Dada; and Johannes R. Becher, Franz Jung, Martin Buber, and others.

It was during this period too that Grosz met Wieland Herzfelde at a gathering in the painter Ludwig Meidner's studio. Herzfelde and Grosz became friends for life despite the differences of ideological opinion that arose be-

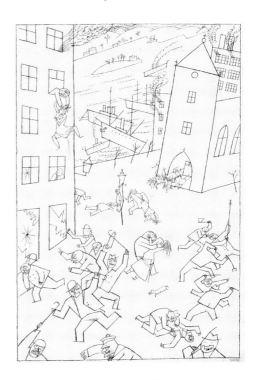

Lunatics Streetfighting, 1915

The City, 1916/17
The first of Grosz's oils to deal directly with the subject of the city. For him it was an apocalyptic place where human problems were concentrated into a confined space governed by individual and collective lunacy.

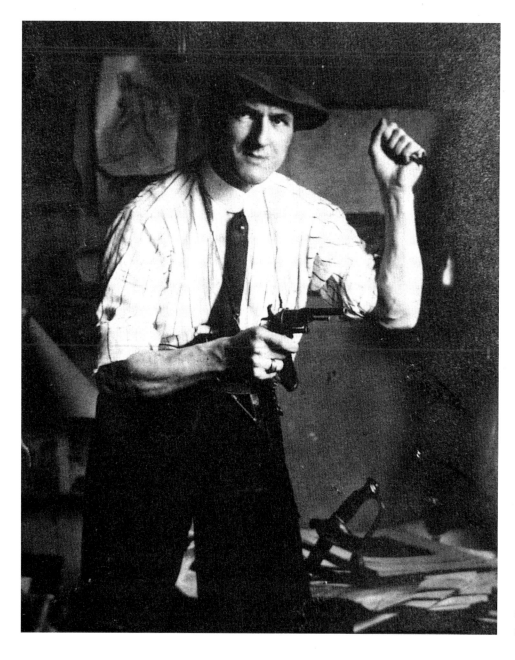

George Grosz with hat and revolver, in his studio, 1918

tween them in later years, when Grosz had turned his back on political commitment. Herzfelde had recently taken over the periodical "Neue Jugend" (New Youth), which made his dealings with the censors easier, since it had been in existence since 1914. "Well presented, the magazine concentrated on lyrical texts of a broadly oppositional tone, essentially Expressionist in their aesthetic bearings." Grosz regularly published poems and drawings in it, and also in Franz Pfemfert's combatively pacifist magazine "Die Aktion", which started out as an Expressionist publication before becoming German soviet in affiliation. "Pfemfert was out to assert the political function of art. It was this above all that set 'Die Aktion' apart from related periodicals such as Herwarth Walden's 'Der Sturm', Karl Kraus's 'Die Fackel' (The Torch) or Alfred Kerr's 'Plan'."

Grosz's enthusiasm for America was visible again in drawings such as *Texas Picture for my Friend Chingachgook* (p.17), based on Fenimore Cooper. This revival of a long-standing interest was prompted not only by dreams of an idealized country of infinite possibilities but also by the wretched circumstances Grosz then found himself in. In 1916 he wrote to

A poem written by Grosz at the same time reads:
"I fire my revolver
early, when I leave the blockhouse
broad, wearing a red and brown shirt –
the dog barks wildly –
and the parrot sings out in English."

Texas Picture for my Friend Chingachgook,
1915/16

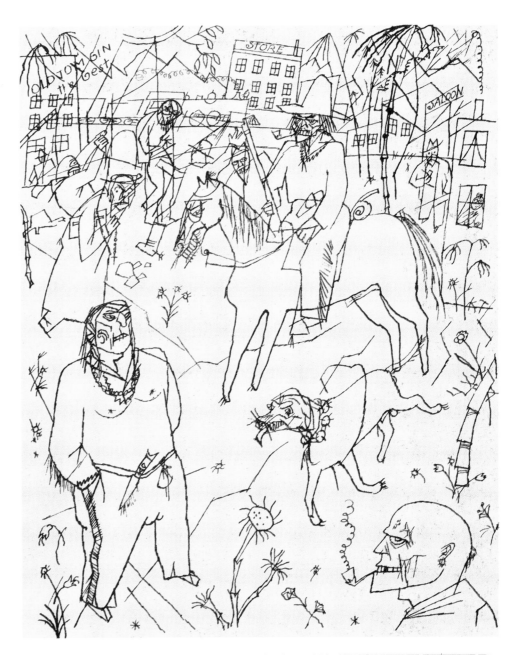

Rudolf Schlichter:
Wild West, 1922/23
The fascination of Grosz, Schlichter and others with America, the Promised Land, fed on westerns and pulp fiction was and reinforced by the wretched economic situation in Germany. Their main sources of inspiration were the German western writer Karl May and James Fenimore Cooper's Leatherstocking tales.

The Metropolis as "Pandemonium"

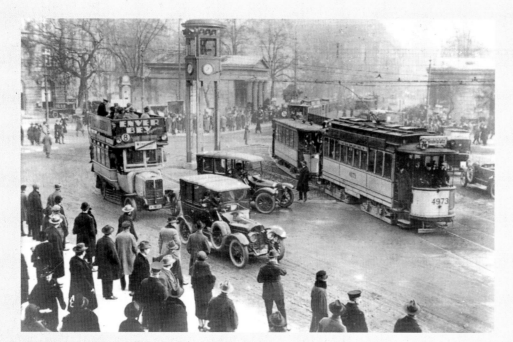

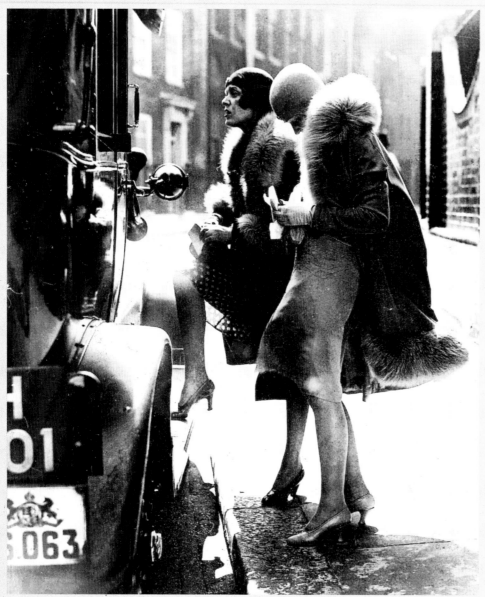

TOP:
City Traffic at Potsdamer Platz, travelling to Leipziger Platz, about 1925

BOTTOM:
Love for Sale, Berlin, 1929

ILLUSTRATION PAGE 19:
Pandemonium, 1914
"What I saw filled me with horror and contempt for human kind," Grosz wrote of the war and German propaganda from 1914 to 1918. Meanwhile, Berlin went about its city business, and in *Pandemonium* Grosz presents everyday life as incessant warfare: arson, rape, hanging, strangulation, stabbing, shooting, battering – it is sheer hell on earth.

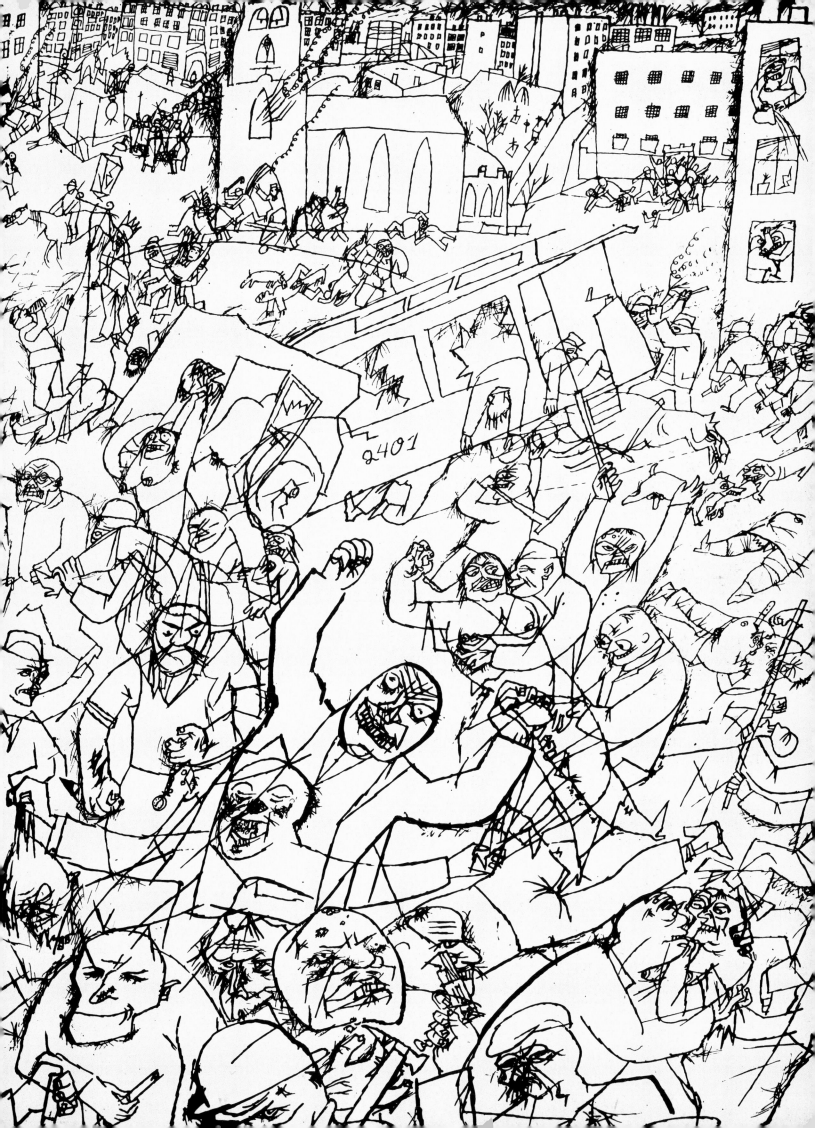

Memory of New York, 1915/16
Though Grosz did not visit New York till 1932, he entitled his second-hand impressions gained from pulp fiction a "memory" of the city.

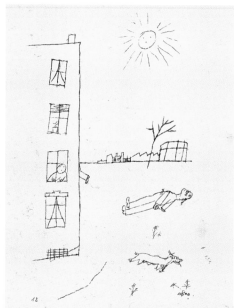

Murder, 1916

his friend Robert Bell: "It is not necessarily a romantic notion if my boyhood thoughts of emigrating to wealthy, victorious America are gaining an ever more secure foothold in my mind these days." It is in this context that we should see his 1916 name change, from Georg Groß to George Grosz – just as Helmut Herzfelde changed his name to John Heartfield. In 1915/16 Grosz drew a *Memory of New York* (p. 20) without ever having been there. It was a world he knew only from pulp fiction, but it fascinated him, and he repeatedly invoked it in poems such as "New York II" (written around 1917):

38 degrees! Wamamaker! Six-day cycle racetrack!
People are hot and wet as sausages in this witches' cauldron!!
Towering 50-cent bazaars continuously spew people out on the streets.
The streets reek and steam.
38 degrees!
There's a warm oily breeze as in giant dynamo rooms,
Somewhere or other red bones are growing out of the ground,

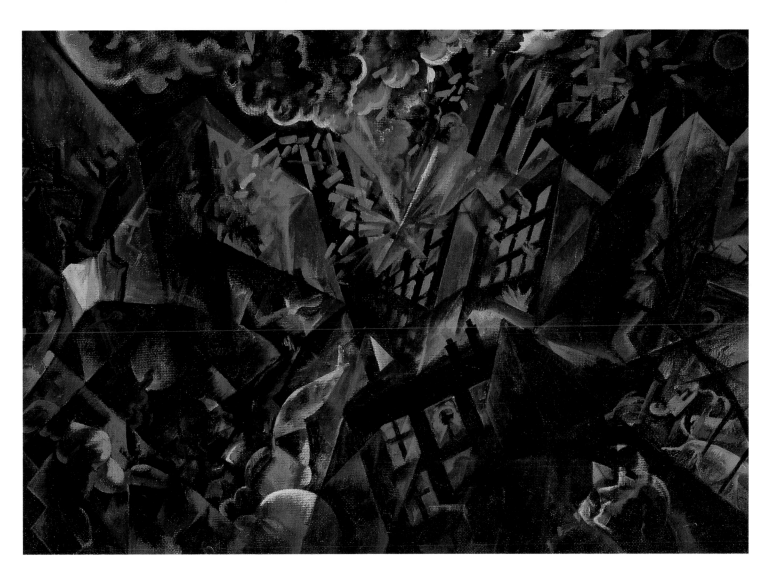

Iron and steel, towering high –
Signs leer, letters dance
Blue, red – Bethlehem Steel Works –
Towering, the nesting boxes hang,
Completed storeys, patches of people and cranes
In fishing nets of iron,
The elevated railway thunders and roars.
Newspapers explode from cars –
And in 28th Street the heat drives a girl
To jump from the tenth floor
– 38 degrees –
Everything bakes, seethes, hisses, bawls, brawls, trumpets, hoots, whistles, reddens, sweats, pukes and works.

Ludwig Meidner:
The Burning City, 1913
Meidner's visionary, apocalyptic cityscapes were among the most idiosyncratic products of the Expressionist imagination.

In 1916 Grosz painted the earliest of his oils that we know of, among them *Lovesick* (p. 23) and *Suicide* (p. 22). The two paintings are closely linked,

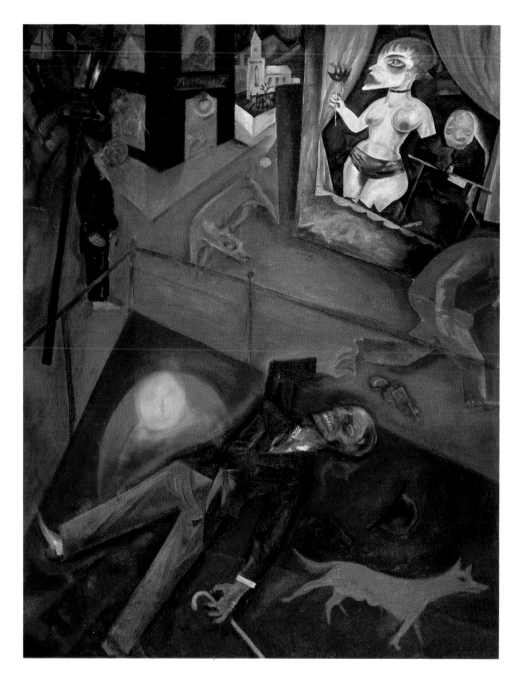

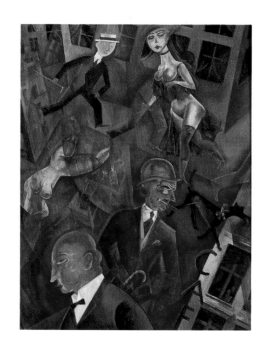

TOP:
Suicide, 1916

BOTTOM:
Metropolis, 1917

and combine Futurist and Expressionist features. The visual space serves at once as interior and exterior: the façades of the latter appear in the former. *Lovesick* tends to be seen as a self-portrait – Grosz the dandy, complete with cane, seated at a café table on which we see his pipe as well as a bottle and other objects. His heart is glowing through his suit jacket, and beneath it is a pistol, suggesting the way out that appears in *Suicide.* Both of these despairing scenes, eloquent of the times as well as of Grosz's personal situation, use dissonant shades of violet, red and green. In *Suicide* the setting is again the city, which for Grosz was a location where madness and the apocalytic throve, as he had already suggested in drawings such as *Pandemonium* (p.19).

The City (p.14) was Grosz's first painting exclusively devoted to city subject matter. (He titled it in English.) When Grosz painted it, he had been called up a second time, spent two months in a psychiatric hospital, and been finally discharged in May 1917. On 30 June that year he described the aim of his picture in a letter to Otto Schmalhausen, in terms every bit as

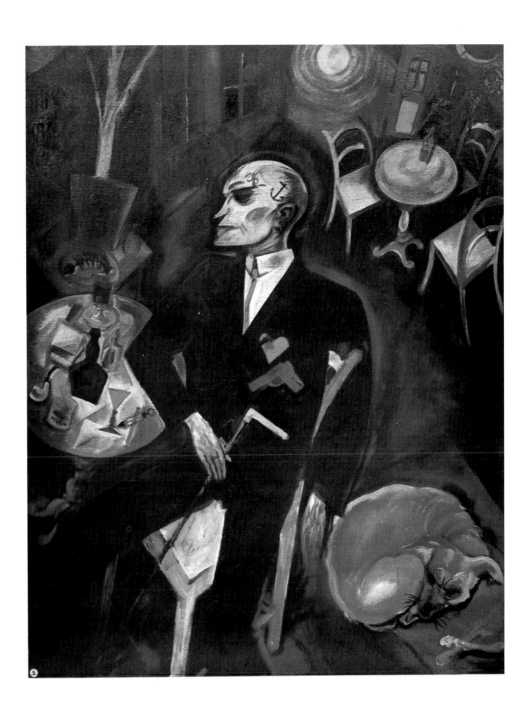

Lovesick, 1916

The two early oil paintings *Suicide* and *Lovesick*, both of which still have Expressionist and Futurist features, are thematically related. The pistol above the lovesick man's heart seems to be suggesting a way out. In *Suicide* the deed has been committed on a kind of stage, with the city in the background, including a brothel and a churchyard.

vivid and wild as the painting itself: "I am up to my neck in visions – and this work expresses my sole emotions, spring-heeled elation, the roaring street scene captured on paper! – or whee, the starry sky whirls about the red head, the tram clangs onto the scene, the telephones ring, a woman giving birth cries out, while knuckledusters and knives sleep peacefully in the stylish sheaths of pimps. Ah, and the labyrinth of mirrors, their gardens of street magic! where Circe changes people into swine, a comical loden hat and coat, or the rum-tum-tiddle walk at the Patéphon, where listeners are held fast by the ear and gramophone music is the palms and the ships you sail away on – or the songs of the signs, the golden 'ronde' of letters – and the nights red as port, nights that eat away your kidneys, nights when the moon and contagion and a ratty hackney driver all come together and a victim has been strangled in the dust-choked coal cellar – oh that city feeling!"

The 1917 painting *Explosion* (p. 21) is an exception in Grosz's work; it bears a strong resemblance to Ludwig Meidner's apocalyptic city scenes (cf. p. 21, bottom). Grosz explored the full potential of the city as subject, and

the exploration unquestionably peaked in *To Oskar Panizza* (p. 25). In retrospect Grosz described it thus: "At night, down a strange street, a diabolical procession of inhuman figures parade by, their faces eloquent of alcohol, syphilis, plague. One is blowing a trumpet, another yelling hurrah. Death rides among this multitude, on a black coffin, symbolized straightforwardly as a skeleton. This picture went straight back to my mediaeval masters Bosch and Brueghel. They too were living in the dawn of a new era and gave it expression. The painting was done in protest at a humanity gone insane." In certain individual and relatively minor figures we see targets of a hatred and post-war despair that went beyond Grosz's purely aesthetic oppositional stance. At bottom left we see a moon-faced priest in triumphalistic pose, both arms upreaching, waving his cross like a flag. In the crowd at bottom right we see military characters brandishing bloody sabres or blowing trumpets, and beside them a hypocrite calling out "Bruder" (brother). Destruction and hatred have become universal, and consume themselves. This city is an inferno peopled by bestial creatures in human guise.

Oskar Panizza, to whom Grosz dedicated the painting in its title, had been brought up in a radically religious fashion, and had become an objector of the most conscientious and rigorous kind. He was repelled by the church, the army, and authority of any sort whatsoever. Panizza was his own analyst in his writings: "I am not an artist, I am a psychopath. Now and then I use artistic form to express myself. When I do this, it is not because I want to play games with shapes and colours, or to amuse or shock the public, but simply to reveal my soul, that whining animal crying out for help." Panizza was twice prosecuted (just as Grosz too was later to face charges), for offences against religion and for defaming the Kaiser. In 1904 he was consigned to a lunatic asylum near Munich. The writer Kurt Tucholsky described Panizza as the most daring, barbed, witty and revolutionary prophet the nation had seen.

In 1917 Grosz also published his first two albums, the "Erste George Grosz Mappe" in the spring, the "Kleine Grosz Mappe" in the autumn (both published by Wieland Herzfelde's new house, Malik). These portfolios contained lithograph drawings done in the last few years. They were advertised in "Neue Jugend".

In 1918, with the meaninglessness of war vivid in his mind, Grosz drew his famous *A1: The Miracle Workers* (p. 28). The scene is the recruiting office. A doctor is examining a spectacled, rotten skeleton and saying "KV" (i.e. kriegsdienstverwendungsfähig – fit for duty – or A1). The drawing was a response to fears of a new conscription wave, which did indeed follow. This time the subject is not drawn from the pulp realm: it is not murder, sex or dissipation, but an altogether concrete situation which Grosz himself felt to be a personal threat. This was the direction Grosz was to take: accusation, and meticulous analysis of social conditions, using carefully observed and universalised situations. He worked with types that stood for whole sectors of experience yet at the same time remained identifiable. The lesson Grosz had learnt was (to adapt a phrase by the art critic Siegfried Kracauer) that pulp may well steal its most mendacious originals from life.

Café, 1915/16

To Oskar Panizza, 1917/18
"At night, down a strange street, a diabolical procession of inhuman figures parade by, their faces eloquent of alcohol, syphilis, plague. One is blowing a trumpet, another yelling hurrah. Death rides among this multitude, on a black coffin, symbolized straightforwardly as a skeleton."

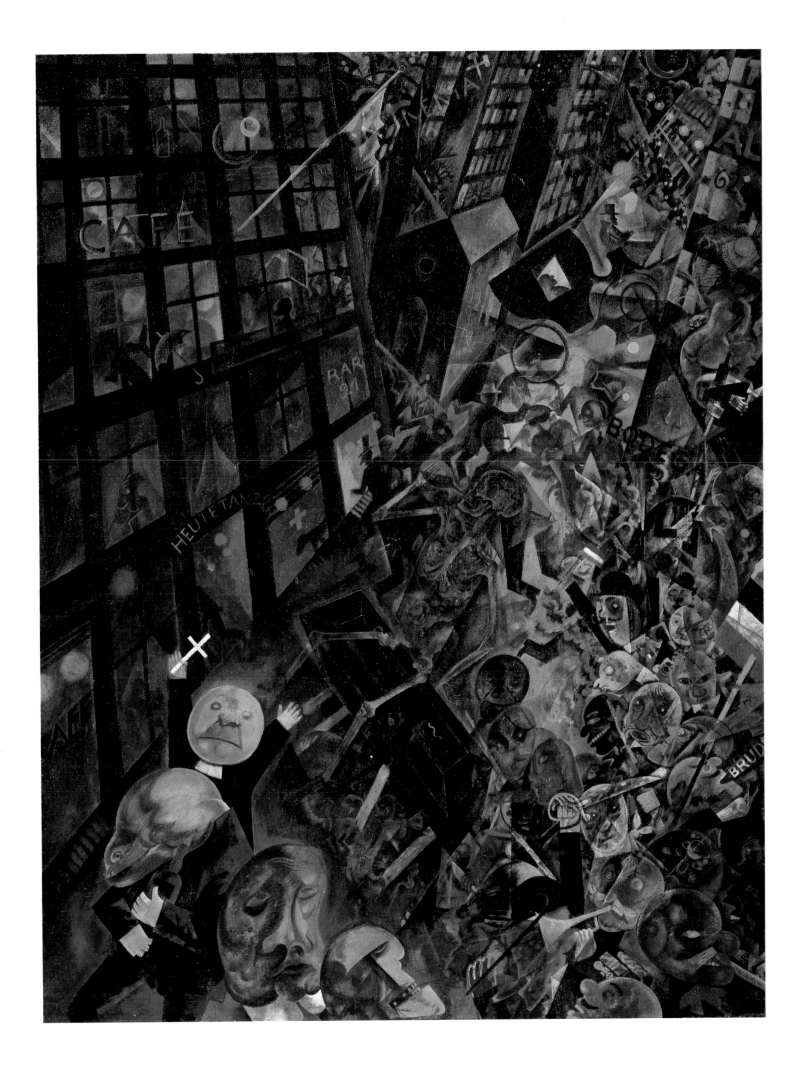

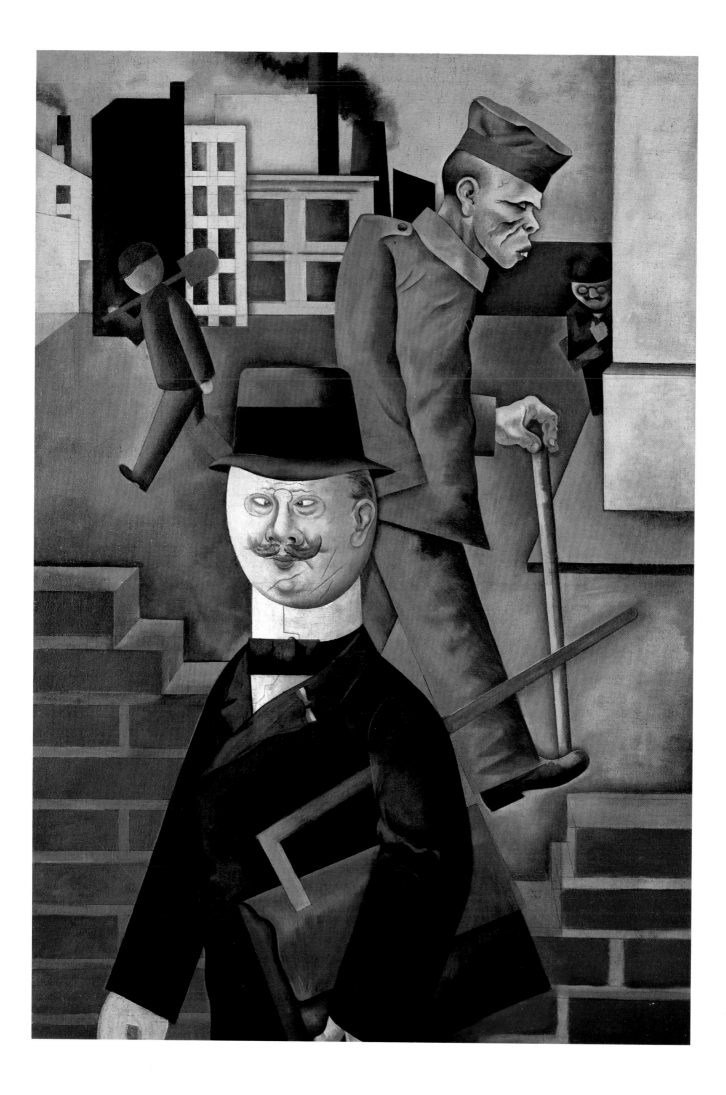

Revolution and Dada

"The German revolt of 1918", historian Sebastian Haffner has observed, "was a social democratic revolution that was suppressed by the social democrat leadership – a procedure unparalleled in world history." On 9 November 1918, Philipp Scheidemann, representing the Majority Social Democrats, proclaimed the republic; on 6 February 1919 the National Assembly convened at Weimar; and on 11 August a new constitution, adopted by the Assembly, was signed by President Friedrich Ebert. The closing months of 1918 had been turbulent. The revolution had begun with a naval mutiny at Kiel on 4 November and had spread to the establishment of workers' and soldiers' soviets throughout the country, inspired by the Russian revolution. On 7 November Bavaria's King Ludwig III was deposed and a socialist government established under the leadership of Kurt Eisner of the USPD (Independent German Social Democrats). In Berlin, on the same day that Scheidemann proclaimed the republic, Karl Liebknecht proclaimed the "free socialist republic of Germany". The (Communist) Spartacist League announced on 10 November that it had no confidence in the socialists now in government, such as Ebert and Scheidemann – a distrust which was to prove justified, since Ebert was secretly in league with General Wilhelm Groener, Ludendorff's successor as Field Quartermaster General. Ebert and Groener had little interest in changing the status quo, and in fact determined to combat Bolshevism. Together with Gustav Noske, the Minister of Defence, Ebert put down the revolution, using troops drawn from the right-wing, nationalist free corps. On 15 January 1919, Karl Liebknecht and Rosa Luxemburg, the figureheads of the revolution, were murdered in Berlin and their bodies thrown into a canal. Grosz's drawing *Remember* (p. 30) did not single out any specific guilty parties, but merely presented a judge in his robes, personifying the Law. And the Law, as the contemporary Heidelberg expert Emil Julius Gumbel found, had a significant share in the responsibility for the collapse of the Weimar Republic. In 1929 Gumbel published a study of vendettas, murders and the legal system in the period 1919–1929; published in Berlin, the book had a drawing by Grosz on the cover.

In early 1919, the Reichswehr and free corps bloodily put down the Munich soviet republic. The drawing Grosz did in response to the atrocities was first published in the USPD magazine "Die freie Welt" (The free world) in June 1919, bearing the title *The Victims of March are washed up* (p. 31). The skyline of the city, including the towers of the Church of Our Lady, is recognisably that of Munich.

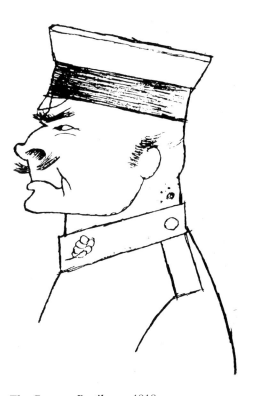

The German Pestilence, 1919

Grey Day, 1921
The architect's square carried by the German Nationalist philistine in the foreground suggests that it is he who is building the wall to separate his world from that of the workers.

Blood is the best Sauce, 1919

In a text published in 1920/21 in "Der Gegner", Grosz made an appeal to the artists of the day: "It is a mistake to believe that if an artist draws circles, cubes or some profound scrawl he is then, in contrast to (say) a Hans Makart, revolutionary. (…) *Your brushes and pens, which ought to be weapons, are nothing but straws.* Get out of your rooms, even if it doesn't come naturally. Get out of your individual isolation, open yourselves up to the ideas of working people, and help them in the struggle against this rotten society."

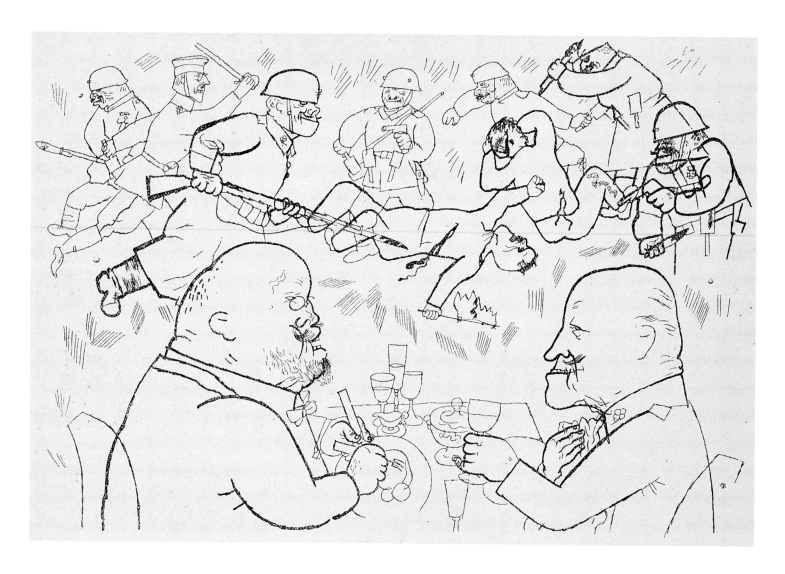

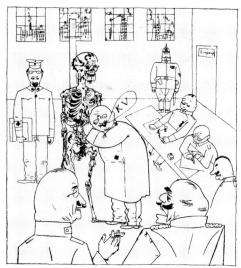

A1: The Miracle Workers, 1918

In 1920 the right wing attempted a putsch, known as the Kapp Putsch. General von Lüttwitz and an obscure East Prussian politician, Wolfgang Kapp, organized two irregular free corps units and seized Berlin. Ebert's government fled, and Noske realised he could not depend on the army; but the putsch, a fiasco, was brought down by a general strike. At the same time, encouraged by the general strike, the Communist Red Army occupied the Ruhr, only to come up against the Reichswehr. Noske resigned, and in the election of June 1920 a minority government under Centre Party leadership was returned, without the participation of a sole representative of the Left (including the Majority Socialists).

Towards the end of 1918, Grosz, Wieland Herzfelde, and the latter's brother John Heartfield joined the Communist Party and the Spartacist League. To show support for the revolution they started a new satirical periodical in 1919, "Jedermann sein eigener Fußball" (Everyone his own Football), which was banned the moment it appeared. Their next publication, which followed immediately, was called "Die Pleite" (roughly: bankruptcy

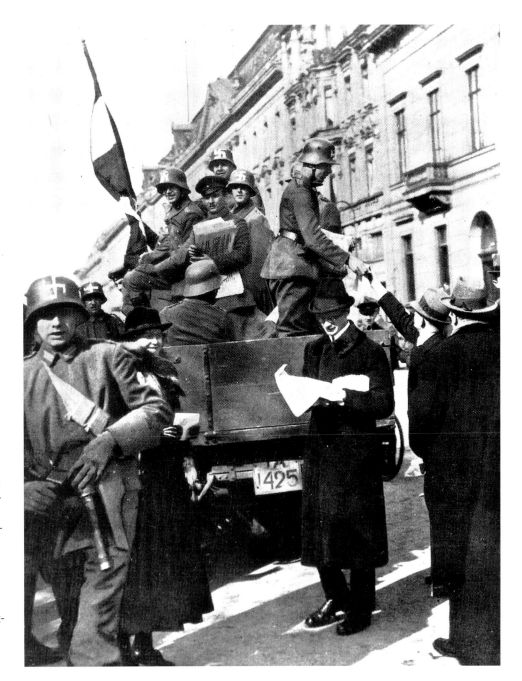

The early years of the Weimar Republic, from 1918 to 1923, were racked by profound political and economic crises. The ruling SPD entered into an alliance of convenience with sections of the Reichswehr and the old bureaucratic powers in order to ward off putschist dangers from left and right. Left-wing social critics (such as Grosz) considered this policy a betrayal of the working class. And time was to prove that the dangers threatening the fledgling democracy from the left were overestimated, whereas the all-too-real danger from the right was not taken seriously enough.

TOP:
Putsch troops with swastikas on Potsdamer Platz, 1920

LEFT:
"Cheers, Noske – the proletariat has been disarmed!", 1919

RIGHT:
The Capitalist and Militarist wish each other a Happy New Year, 1920

Sectarian Murders and Miscarried Justice

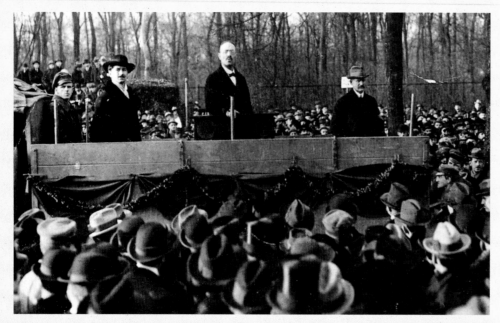

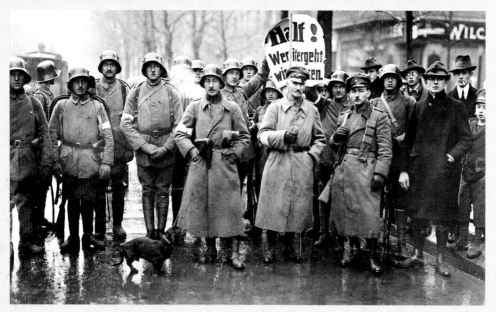

TOP LEFT:
Remember, 1931

TOP RIGHT:
Rosa Luxemburg

CENTRE:
Karl Liebknecht speaking in Berlin, 1918

BOTTOM:
Spartacists in Berlin, 1919

ILLUSTRATION PAGE 31:
The Victims of March are washed up, 1919

Political murders, committed generally by the right wing, were routine in the Weimar Republic. Among the best-known victims were the socialist leaders Rosa Luxemburg and Karl Liebknecht, both murdered by the free corps in 1919. In *Remember* (top left), Grosz accuses not the murderers themselves but the legal system, personified in a judge. The blindness of the Law to right-wing violence was a significant factor in the fall of the Weimar Republic.

or disaster). It too did not survive into a second issue, since Wieland Herzfelde was taken into "protective custody" – a phrase which was then adopted as a title for the next publication. The first six issues of this periodical were legal, but it was then banned and the next four were published illegally. Grosz co-edited some of the issues, and contributed a large number of drawings.

"In artistic terms," noted Grosz, "we were all Dadaists at that time." (YN p.129) The first Dada evenings had been held in 1916 at the Cabaret Voltaire in Zurich, from where Richard Huelsenbeck imported the ideas to Berlin. In Berlin, Huelsenbeck claimed, Dada served a different purpose: "While Dadaism in the Entente countries, under the leadership of Tristan Tzara, is not so very different from 'l'art abstrait', Dada in Germany – where psychological conditions for activities of our kind are quite different from those in Switzerland, France or Italy – has acquired a distinctively political character."

Dada began while the First World War was still raging, in response to the insanity of the real world. In "En avant dada", his history of Dada, Huelsenbeck mounted a polemical attack on what he saw as "salon" Dada à la Tzara. Together with Raoul Hausmann he drew up a programme that was plainly different from the Zurich movement's:

"Dadaism demands

1. the international revolutionary association of creative and intellectual persons throughout the world in the spirit of radical Communism;

2. the introduction of incremental unemployment linked to wide-ranging mechanization of every field of activity. Only unemployment assures the individual of an opportunity to assess the truth of his own life and be finally reconciled to experience;

3. the immediate expropriation of property (socialisation) and Communist food for all, and the creation of garden cities and cities of light, to be the common property of all and to help mankind evolve towards freedom."

Furthermore, a "Dada revolutionary central council" (thus the signatory of the programme) advocated a list of measures from "a) the daily public provision of food for creative and intellectual persons on Potsdamer Platz (Berlin)" to "k) immediate governance of all sexual relations, in the spirit of international Dadaism, by the establishment of a Dada sex centre."

What the programme implied was destruction, including a planned self-destruction. The Dada movement, originating in Zurich, had spread in a variety of forms to Paris, New York, Berlin, Cologne and Hanover. In France, to over-simplify, Dada evolved into Surrealism, which in turn attracted the Cologne artist Max "Dada" Ernst. Kurt Schwitters in Hanover occupied the position of an outsider.

Grosz's *Germany: a Winter's Tale* (p. 33) was painted from 1917 to 1919. (The title was taken from the poet Heinrich Heine, "Deutschland. Ein Wintermärchen".) It is widely considered one of the seminal works in 20th-century socio-critical art. In the middle of the picture, surrounded by the familiar turmoil of city chaos, sits a rotund philistine clutching his knife and fork, gaping with bewilderment. Before him is a plateful of gnawed bones and a bottle of beer with the Iron Cross on the label. These, and his cigar and newspaper, satisfy the good citizen's needs. Below we see the triumvirate that underwrite his society: the priest, the general and the teacher, the last puffy-cheeked and bulbous-nosed, double-chinned and thick-necked, cane in hand

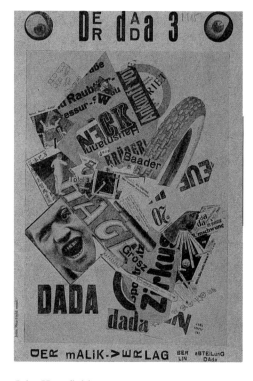

John Heartfield:
Dada 3, 1920
Heartfield was the brother of Wieland Herzfelde, who founded Malik Publishing. John Heartfield's photomontages for the "Arbeiter Illustrierte Zeitung" and "Volksillustrierte" papers made him famous.

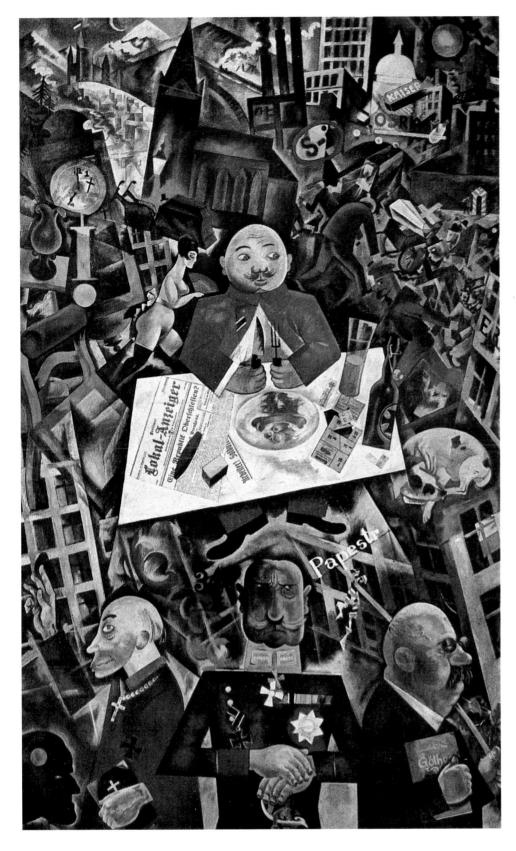

Germany: a Winter's Tale, 1917/19
Grosz took his title from Heinrich Heine's poem of 1844, which was a biting, witty, merciless exposé of the Germany of his day. Grosz was continuing Heine's critique by other means – those of the artist.

and a volume of "Göthe" (i.e. Goethe) held to his breast. Grosz returned to the subject of this lower part of the painting in his 1926 *Pillars of Society* (p.73). At the bottom left, an adumbrated profile of the artist appears in silhouette, jaw out-thrust in fury.

Once again Grosz was drawing upon late mediaeval approaches to composition, adapted to Expressionist-cum-Futurist purposes. His personification of the enemies of democracy was already sharper than in *To Oskar Panizza* (p.25). Grosz's work at this time eloquently articulated the political aims of

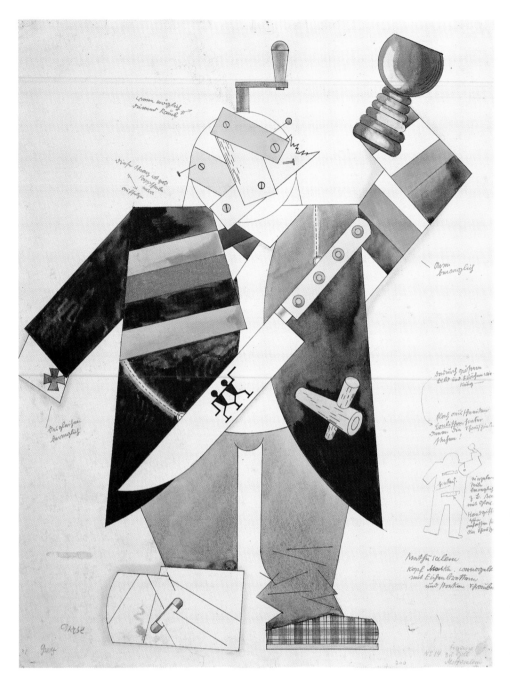

TOP:
Methusalem, 1922
One critique of the political and social state of affairs was artistically expressed in Dada. Huelsenbeck proclaimed that the Dadaist's instinctive mission was to smash the Germans' cultural ideology.

BOTTOM:
John Heartfield with Grosz's puppet of a *Conservative gentleman,* 1919

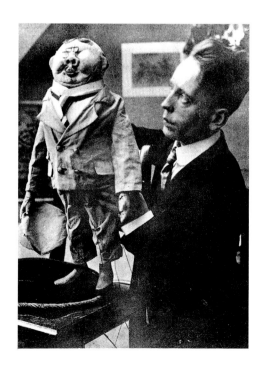

the Berlin Dadaists. Grosz's sympathies were with the soviet movement, which professed to be radical in its democratic objectives.

Count Harry Kessler, a diplomat and patron of the arts of whom Grosz wrote in his autobiography that he was perhaps the last true gentleman, left a diary with a vivid account of the period. On 5 February 1919, Kessler recorded his impressions of the painting and of Grosz: "This morning visited the painter George Grosz in Wilmersdorf (Nassauische Straße 4). Wieland and Hellmuth Herzfelde there. Grosz had a big political painting, *Germany: a Winter's Tale*, poking fun at the ruling classes, the pillars of the well-fed indolent bourgeoisie (bolster). He said he would like to be the German Hogarth, deliberately concrete and moral; to preach, ameliorate, reform. [...] Then Grosz said that art as a whole was unnatural anyway, an illness; the artist was obsessed, a man possessed of a mania. The world did not need art, he said; people could get by without art." Kessler describes Grosz a Bolshevik of art, nauseated by painting, concluding: "In fact his thinking is in part rudimentary, in terms of its intellectual substance, and easy to contest."

Dada's activities included soirées (the first in Berlin was on 12 April 1918), matinees, cabaret performances, and other similar events. At a Sunday matinee on 7 December 1918 in the Charlottenburg district of Berlin, for instance, Walter Mehring and George Grosz organized a race – between a sewing machine and a typewriter. The most spectacular Dada event, the "first Dada trade fair", was held in summer 1920 at Dr. Otto Burchard's commercial art gallery in Berlin. Organized by Grosz, John Heartfield and Raoul Hausmann, this exhibition included work by Grosz, Heartfield, Hausmann, Hannah Höch, Max Ernst, Otto Dix, Hans Arp, Rudolf Schlichter, Francis Picabia, Grosz's brother-in-law Otto Schmalhausen, and others. In his introductory comments, Wieland Herzfelde wrote of the Dadaists' aims: "The Dadaists say: if in the old days people spent endless amounts of time, love and hard work on painting a body, a flower, a hat, a shadow etcetera, all we need do now is take a pair of scissors and cut out whatever we need from photographic reproductions of those paintings. And if the things we want are not too big, we do not even need representations of them but can use the things themselves – pocket knives, ashtrays, books etcetera – all kinds of things that have been very nicely painted in the old art in museums, but no more than just painted." The Dadaist, Herzfelde continued, had to press on with the processes of social and political disintegration currently visible everywhere; and for that reason their art had to be contemporary in tenor. The technique of collage or montage he had described, which originated in Cubism, was used by Hannah Höch and John Heartfield, and perfected by Max Ernst, who was to make it his central artistic principle.

Responses to the Dada show ranged from shock to "sheer nonsense". Even so, it was to have legal consequences, as Raoul Hausmann recorded in 1921: "From the ceiling of the gallery, a stuffed soldier dressed in field grey hung suspended, wearing officer's epaulettes and with a pig mask under his cap. Against the wall stood a stuffed female torso made of black canvas, with neither arms nor legs and with a rusty knife and broken fork stitched to

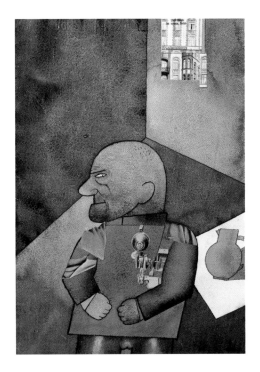

Monteur Heartfield, 1920

BOTTOM LEFT:
The Dada Exhibition at Burchard's Gallery, 1920

BOTTOM RIGHT:
Grosz and Heartfield at the opening of the Dada Show, 1920

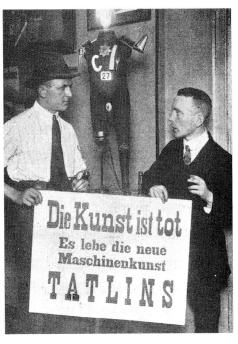

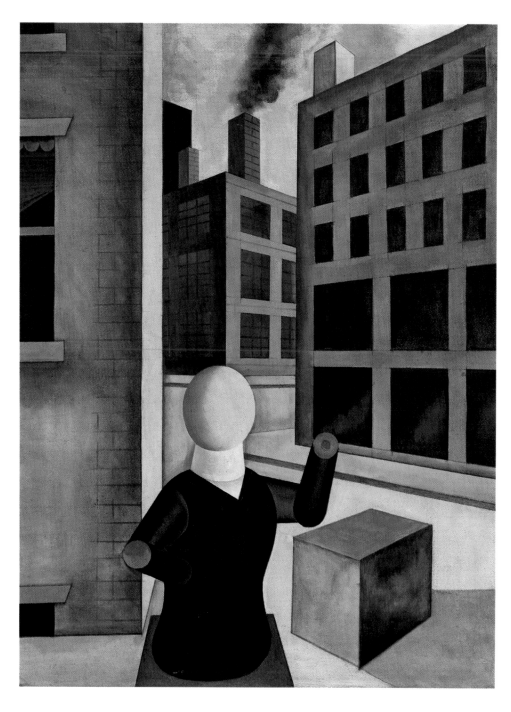

Untitled, 1920

her breast. On one shoulder she had an electric bell, on the other a spirit stove. On the woman's derrière was an Iron Cross. The exhibition also featured an album, displayed open, titled 'God on our side', which included cartoons of army types. This album had been published by Malik, the proprietor of which house is Herzfelde, the accused; and the pictures were done by the other accused party, Grosz."

Grosz's album, his third, published in 1920 in an edition of 125, was subtitled "Political Portfolio". He was charged with defamation of the Reichswehr. The defence witnesses at the trial included Paul Ferdinand Schmidt, curator of the Dresden City Art Collection, and the writer Stefan Großmann. The latter stated that he had not been at all outraged by the contents of the album, while Schmidt declared Grosz to be one of the most powerful and significant of contemporary artists. The public prosecutor nevertheless ruled that the various exhibits had indeed defamed the army. He demanded that

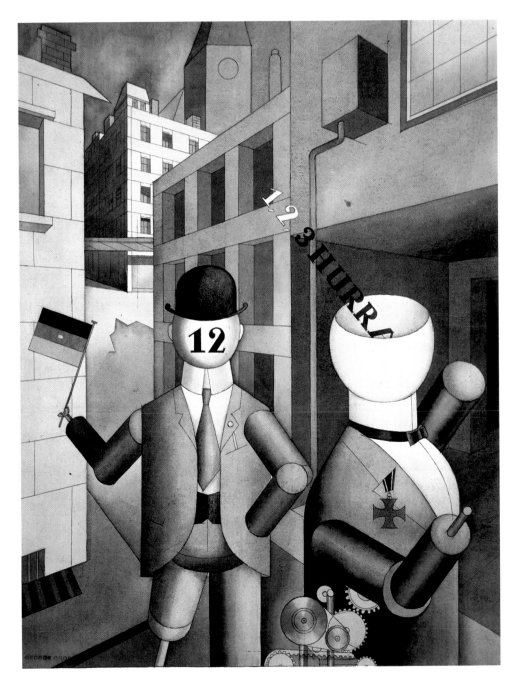

Otto Burchard and Rudolf Schlichter (who had made the stuffed soldier wearing the pig mask) be fined 600 marks each, and Grosz and Herzfelde sentenced to six weeks in prison each. In fact only Grosz (300 marks) and Herzfelde (600 marks) were fined. The plates from which the portfolio had been printed were confiscated, and the power to licence publication was placed in the hands of the Ministry of Defence.

The exhibition roughly signalled the end of the Dada movement in Berlin. Grosz had been producing barbed political drawings and paintings which are among the most telling witnesses to the closing phase of the First World War and its immediate aftermath. But he had also been painting in a style influenced by the "pittura metafisica" of Italian artists such as Carlo Carrà and Giorgio de Chirico (cf. pp. 36 and 37). This style called for straight, linear visual spaces peopled by doll-like automaton characters, the idea being that industrialization and technology were robbing human beings of their indi-

Republican Automatons, 1920
Dada's determination to shock the bourgeoisie was paralleled in Italian Futurism. During the Dada period, works were painted in Germany that betrayed an obvious debt to the "pittura metafisica" of Carlo Carrà and Giorgio de Chirico. The mechanistic, puppet-like figures and eerily deserted architectural settings are characteristic.

viduality and mechanizing their lives. In the German context, this attitude dated back to the Romantics of the early 19th century. Thus the writer Jean Paul, for instance, had observed: "From time immemorial, mankind has produced machines that stole the bread from people's mouths by doing their work better and faster. For, as bad luck would have it, machines invariably do good work and outstrip human beings. For this reason, men in office who aspire to higher things than idle mediocrity are forever doing their utmost to act mechanically and at least imitate machines if they cannot actually 'be' machines."

In these pictures we first see a new objectivity or sobriety ("Neue Sachlichkeit") in the underlying view of the world. The painter Amédée Ozenfant saw pictures – much like Le Corbusier's view of houses as "machines for living" – as machines meant to move people. This attitude reappears in Francis Picabia, Max Ernst and Marcel Duchamp; in the Bauhaus (we need only recall an Oskar Schlemmer); or, among Grosz's closer associates, in Rudolf Schlichter and Raoul Hausmann. "People are no longer portrayed in individual terms, with meticulous psychological insight," noted Grosz, "but as a collective, almost mechanical thing." During this period he rubber-stamped his work, rather than signing it, with the words "constructed by George Grosz".

In that same year of 1920, Grosz married Eva Peters. His collage *Daum marries her pedantic automaton George…* (p. 39), exhibited at the Dada show and later included in the album "Mit Pinsel und Schere, 7 Materialisationen" (Brush and Scissors: 7 Materializations) (1922, Malik), was intended as a kind of wedding picture. Grosz, the automaton, is posed next to a baby-doll woman, genitals and breasts exposed, who is turning to look at him. At the top left, a photograph of Eva Peters has been stuck on. The background is soullessly architectural, in muted colours.

The automatized human got his face back presently but remained a type rather than an individual. *Grey Day* (p. 26), painted in 1921, still recalls "pittura metafisica" in its stylized, anti-human architecture and its approach to the human figure. The four-square philistine bourgeois in the foreground is identified by the black-white-red buttonhole ribbon as German National in his sympathies, and his stand-up collar, fraternity duelling scars, waxed moustache, pince-nez and absurd hat all confirm the image. The draughtsman's square suggests that he is the builder of the wall that separates his kind from the world of the workers – where we see the second prominent figure in the painting, that of a mutilated war veteran. The good citizen's squint implies he has a cross-eyed view of the world that is all his own; the cripple's eyes are downcast – he has no reason to share the other's witless self-assurance. The scars of the one-armed man bear witness to a real war, not to the games played by fraternities. These two clearly defined types in the foreground are recapitulated in a non-individual, faceless form in the background, and Grosz's implication is plainly that the contrast is repeated into infinity, universally.

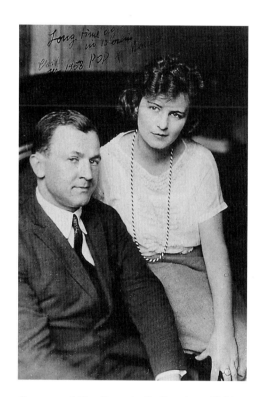

George and Eva Grosz in Berlin, about 1924

Daum marries her pedantic automaton George in May 1920, John Heartfield is very glad of it, 1920
Grosz made this collage on the occasion of his marriage to Eva Peters: it served as a wedding picture, as it were. Daum was an anagram for Maud, Grosz's pet name for Eva. He himself is (ironically) the pedantic automaton.

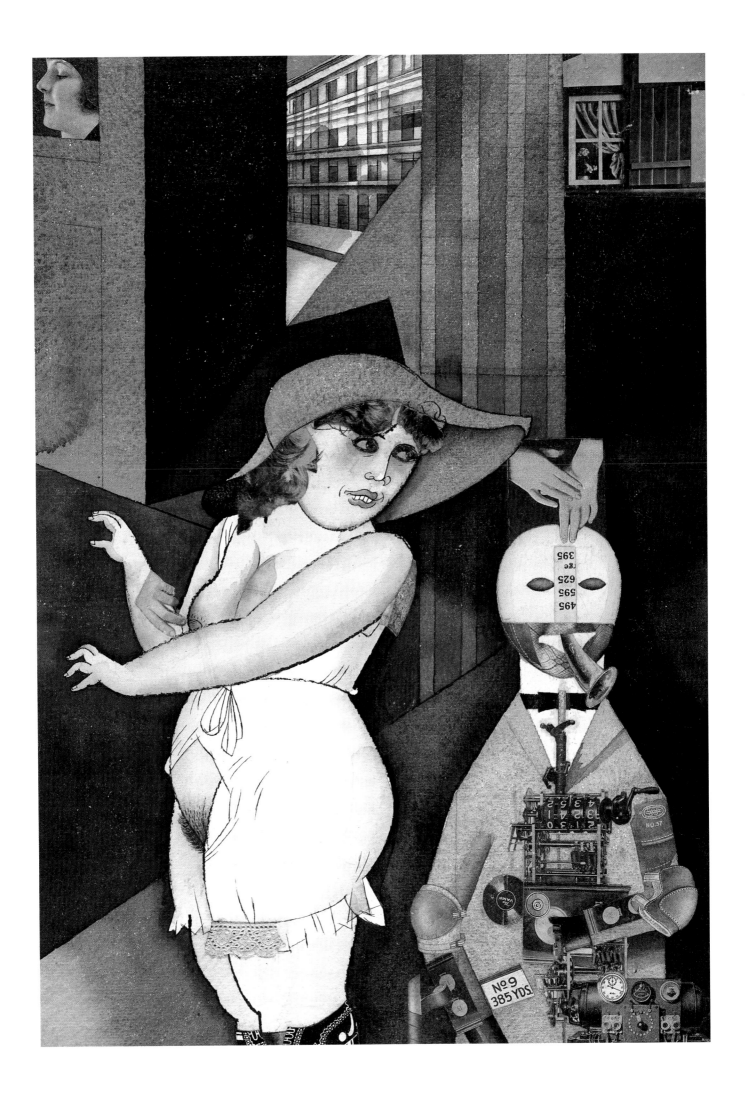

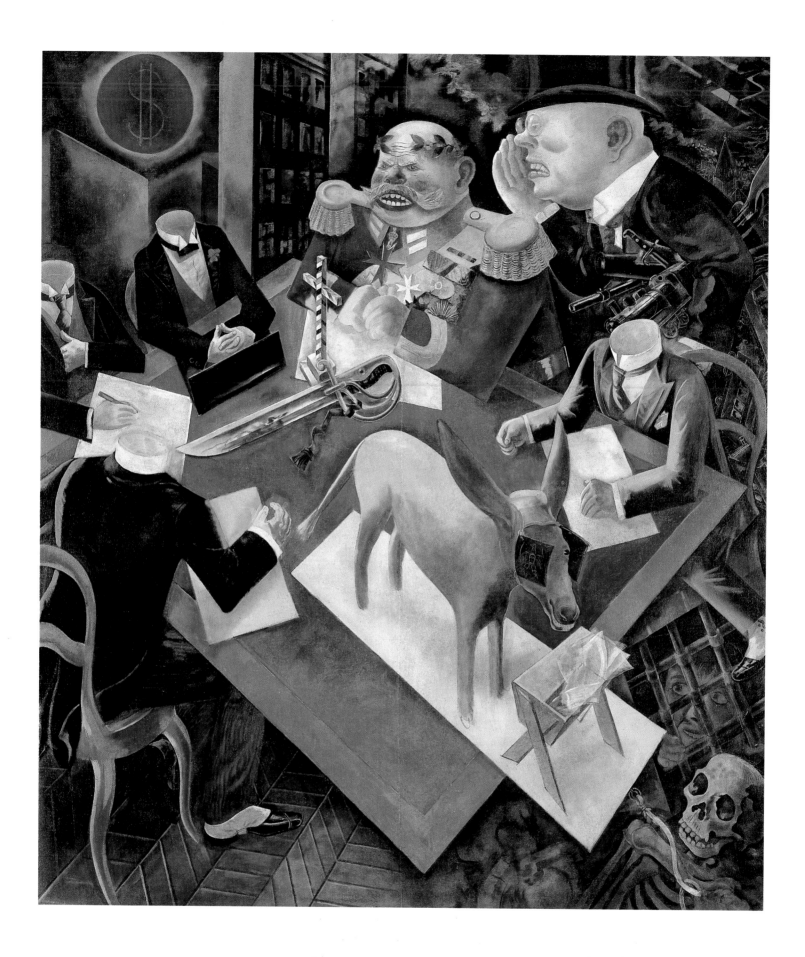

Weapons and Straws

At this point, with Dada over and a stable period in the Weimar Republic's history still to come, it makes sense to pause and consider the principles and strategies Grosz had evolved by that time and which were essentially to govern his later work as well. It will be helpful to look both ahead and back as we do this. On the one hand, Grosz's work was explicitly contemporary, and thus dependent on the period in which it was made; but on the other, he aimed (as his express mention of artists such as Bosch or Brueghel shows) beyond his own time, hoping for universality.

Critics generally claim that the mainspring motive in Grosz's art was hatred. This view runs from the writer Carl Einstein, who had worked with Grosz on "Die Pleite" and "Der blutige Ernst" and published a study of 20th-century art in 1926, to the critics Hans Hess and Uwe M. Schneede in the 1970s. In his preface to "Drums in the Night", Bertolt Brecht wrote: "The bourgeoisie accuse the proletarian of having a bad complexion. I think what makes you the enemy of the bourgeoisie, George Grosz, is their physiognomy."

In Grosz's earlier drawings, such as *Pandemonium* (p. 19), the world was presented as sheer chaos, a madhouse in which destruction, murder, theft and rape prevailed. The city was at once the setting and the symbol of this world. Life was a struggle: "Man is not good – man is an animal! Mankind has created a despicable system with some on top and the rest underneath. Some earn millions, while thousands upon thousands can barely subsist." Thus Grosz in his piece "Instead of a Biography". Grosz portrayed this hell on earth, in all its lunacy, in cross-sections with neither beginning nor end. The individual is merely part of the turmoil in which he (unconsciously) participates. Similar principles are visible in the major works *The City* (p. 14), *To Oskar Panizza* (p. 25) and *Germany: a Winter's Tale* (p. 33). In the last of these, specific physiognomic types become increasingly defined, and we can see the direction Grosz is set to take. Those responsible for the world's misery (he is saying) are the very ones who sustain the status quo and block reform. The average citizen is passive, or even approves. Grosz zooms in on a chaos he had initially presented in generalized form, highlighting his subjects and concentrating on them in paintings and drawings such as *The Pillars of Society* (p. 73) or *Eclipse of the Sun* (p. 40).

Grosz evolved a cast of types that depended on deformation to make their impact, stressing specific features. As the art critic Hans Platschek has aptly noted: "There can be no doubt that Grosz was motivated by hatred, but what

The New Generation, 1921/22

Eclipse of the Sun, 1926
Since the politicians seem to have lost their heads, the army and capitalists are dictating what is to be done. The people – symbolized by the blinkered ass – simply eat what is put before them.

counts is not the feeling itself but how it is articulated – in this case, as denunciation." As the political situation was consolidated, Grosz's drawings lost their edge and shrillness (though without forfeiting their sureness of touch). His types, as in *The New Generation* (p. 41) or *The Best Years of their Lives* (p. 51), invite comparison with real life.

Grosz's skill with the zoom shot, the close-up, is best seen in *The German Pestilence* (p. 27). We have Wieland Herzfelde's word for it that "the original of the impressive cover drawing for 'Pleite' no. 5 is no bigger than a postage stamp. It is a detail from a drawing, 'Berlin – Friedrichstr. 1918', on which there are a large number of faces, some of which we have already used in a similar way."

Before the First World War, Grosz had already been planning a three-volume opus entitled "On the Ugliness of the Germans". It was to have been an idiosyncratic analysis, polemical and pointedly overstated but no less "true" for all that. The photographer August Sander, too, had begun in 1910 to record an unbiassed cross-section of the population; in 1929 a selection of his portrait photos was published. He had a large-scale work in mind, "People of the 20th Century", to comprise forty-five albums each of twelve photographs. Of these pictures, the novelist Alfred Döblin wrote: "This is a kind of cultural history, or rather sociology, of the past thirty years."

In analogous vein, Walter Mehring wrote in his foreword to Grosz's 1925 book "Der Spießer-Spiegel" (A Mirror for Philistines): "This took years of tireless, constantly vigilant observation, lying in wait for the philistine when he thought himself unobserved. Thus Grosz has both the accuracy of the practised hunter and the precision of the scientific conservationist. And he not only skins his bagged philistine with an expert touch, without damaging parts as sensitive as the delicate snout or the loops on his boots, but he also presents the prepared specimen in a posture of such verisimilitude, and pads the rolls of fat so true to life, that one involuntarily doffs one's hat or stands to attention."

Drawings from "Der Spießer-Spiegel", 1925
These drawings reflect a change in political circumstances. From 1924 to 1929, the Weimar Republic enjoyed a temporary stability. Grosz registered the change in climate by concentrating on observation rather than agitation.

People, 1919
Grosz laid down one of his key principles in 1930: "The devil knows why it should be so, but once you look more closely, people and things begin to look threadbare, ugly, and often pointlessly ambiguous."

It was said that Grosz had become weaker; but if we compare the immediate post-war period with the mid-Twenties, it would clearly have been pointless to go on drawing in the self-same manner. The revolutionary urge had petered out or been put down. The bourgeoisie had confirmed their position and were more secure than ever. The sociologist Siegfried Kracauer described and analysed the lower middle classes in late Twenties Berlin in his book "Die Angestellten" (The Employees). "Quotations, conversations and observation on the spot were the cornerstone of Grosz's work. He did not set out to illustrate a theory. Rather, he was presenting case studies, instances of the real."

The three types of social analysis we have now seen – by the Grosz of the later Twenties, by Sander and by Kracauer – are essentially similar. Sander and Kracauer are as disinclined as Grosz to observe a scholarly neutrality. Their diagnoses are as loaded as Grosz's.

Decadent Society and its Critics

TOP:
Wieland Herzfelde, Eva and George Grosz,
Rudolf Schlichter, John Heartfield, 1921

BOTTOM:
George Grosz in his studio, 1920

ILLUSTRATION PAGE 45:
Five in the Morning!, 1920/21
"Man is not good – man is an animal! Man-
kind has created a despicable system with
some on top and the rest underneath. Some
earn millions, while thousands upon thou-
sands can barely subsist."

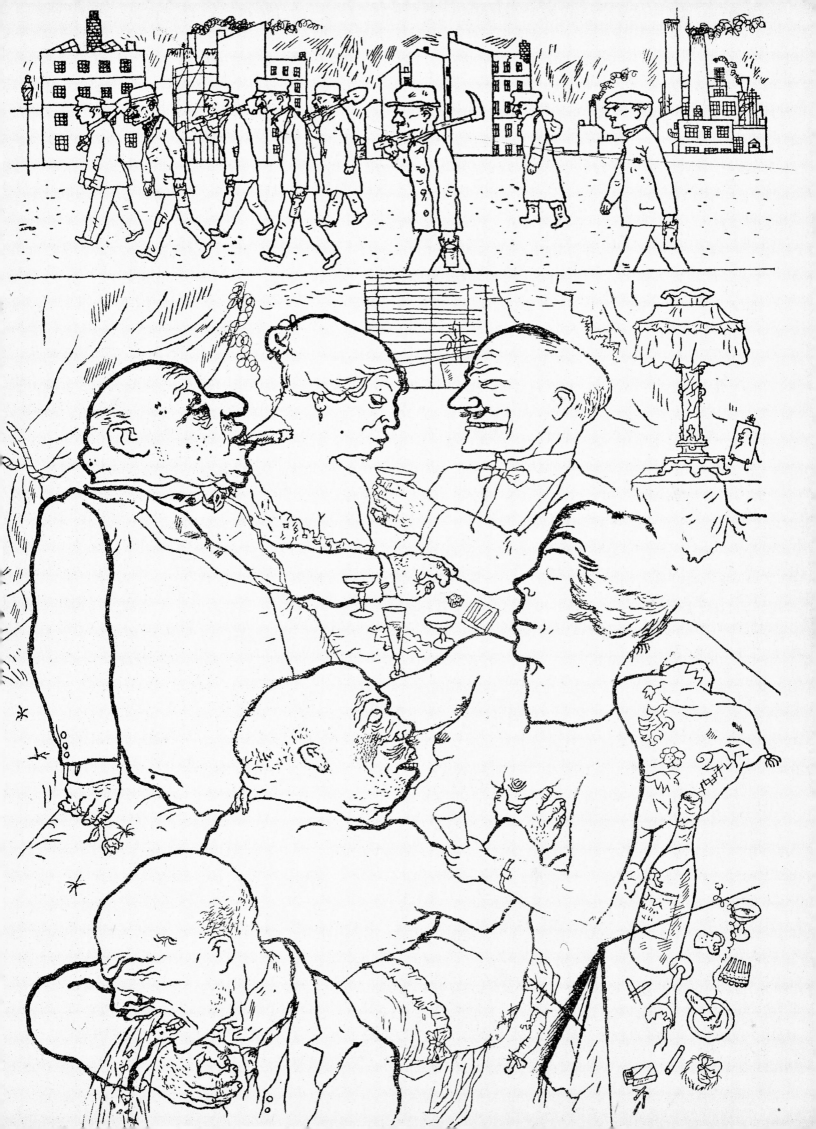

Probing dissection was not Grosz's only approach. Another strategy was what we might term dialectic juxtaposition, a technique we have already seen in a first, exploratory form in *Grey Day* (p. 26), as in the drawings *Blood is the best Sauce* (p. 28) or *Five in the Morning!* (p. 45). In both drawings, Grosz presents two distinct areas of life in opposition, and implies that they function as cause and effect. In the former, the capitalist and the militarist are dining together in "refined" style, while in the background soldiers are taking delight in butchering people the German title informs us are Communists (Die Kommunisten fallen und die Devisen steigen). The capitalist is the now familiar fat man with a curled moustache and thin beard, wearing a pince-nez, while the militarist is angular, with a jutting, aggressive jaw. Grosz's message is crystal clear: that the bloody suppression of the revolt reinforced the alliance of capital and the army and served to maintain the old order. The two areas presented in the drawing are intimately related; they happen simultaneously and indeed are mutually dependent. The murders take place before the very eyes of the diners. They take no interest, however, and do not even pause to look at what is simply business as usual. The drawing was done in 1919, the year when Rosa Luxemburg and Karl Liebknecht were murdered and revolutionary hopes were quashed.

Five in the Morning! was done in 1920/21 when the centre-right coalition had been established. Conditions had stabilized somewhat: the soviet nonsense had been thrashed out of the workers, and everything was back to normal. In *Blood is the best Sauce*, the coherent use of space implied critical in-

TOP:
Orgy, 1920
Grosz targeted not only the "pillars of society" – politicians, lawyers, military and ecclesiastical leaders – but the bourgeoisie in general. He saw the entire class as a decadent mire which nurtured the power of the ambitious.

ILLUSTRATION PAGE 47:
Dusk, 1922

teraction between the two areas, but now that link has been severed and the separation of the classes re-established. In the smaller strip at the top we see workers on their way to work, while below the dividing line the capitalists, whose features and characteristics we are familiar with, are living it up with women and champagne, and one is throwing up. All of this at five a.m. Again the principle of simultaneity, asserted in the title, applies, but this time the divide is emphasized.

Grosz was also attempting to draw not from hatred but from compassion. The critics claim he failed. But if we compare Sander's photograph *Unemployed* (p. 49, top) with Grosz's 1924 drawing of a poor woman (p. 49, bottom right), it is striking that both employ pure naturalism to prompt fellow-feeling. The problem here is that a Grosz who is seen only as a corrosive satirist is necessarily found to be weaker if he creates work in accordance with different principles. If it is weakness, though, it is weakness implicit in the method.

Another of Grosz's central principles related to his approach to the printing and reproduction of his work. In 1917, as we have seen, the first album was produced, in four versions, in a total run of 120. The most expensive version, a half-cloth edition costing forty marks, included all nine transfer lithographs from drawings some of which dated some time back, signed, and printed on heavy Japanese woodcut paper. The cheapest version, unsigned

Sauve qui peut!, 1922
Alongside Grosz's aggressive, "j'accuse" drawings there are others of a gentler, compassionate nature. Unemployment and poverty were among the acute problems which Grosz and other artists tackled in sober, realistic manner.

and on normal paper, cost 20 marks. Subsequent albums were produced along the same lines. Sometimes they were also run in book format at a cheap rate. The famous "Ecce homo" album (1922/23), for instance, appeared in a total edition of 10,000; there were three versions of the loose-leaf album, and two bound book editions. The earlier albums were transfer or photographic lithographs, but "Ecce homo" was offset printed. The more opulent and expensive editions had the impress of a (purely imaginary) plate edge stamped into the paper. The work included an impressive 84 reproductions from black and white drawings and 16 colour prints from watercolours.

In addition, Grosz published numerous books that were marketed solely as such. One such was "Das Gesicht der herrschenden Klasse. 55 politische Zeichnungen" (The Face of the Ruling Class. 55 Political Drawings) (1921); another was "Abrechnung folgt! 57 politische Zeichnungen" (Reckoning up. 57 Political Drawings) (1924); and there were more beside. The drawings in these albums and books were not made specifically for these publications but were chosen from work that Grosz had already done.

Many of his drawings, indeed, appeared several times in print. *A1: The Miracle Workers* (p. 28), for instance, a drawing made in 1918, was published in 1919 in the third issue of "Die Pleite", included in the album "Gott mit uns" (God on our side) in 1920, and again included in "Das Gesicht der herrschenden Klasse" in 1921. Many of Grosz's other drawings were similarly reproduced and re-used in various ways.

Around 1920, Grosz did not see himself as an artist: "All these things, the people and phenomena, I drew meticulously. I loved none of it, neither what I saw in the restaurants nor what was in the streets. I had the presumption to see myself as a scientist, not a painter or indeed a satirist." (YN pp. 121–2) Grosz's "Instead of a Biography" makes his position even clearer than his autobiography does. There, he turned ferociously upon bourgeois art and the artists who produced it: "Are you making any attempt to experience and

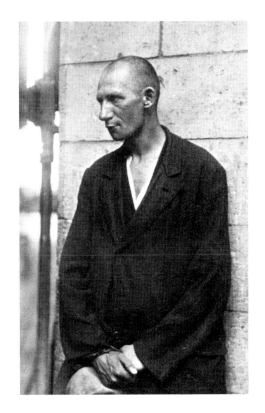

August Sander:
Unemployed, 1928

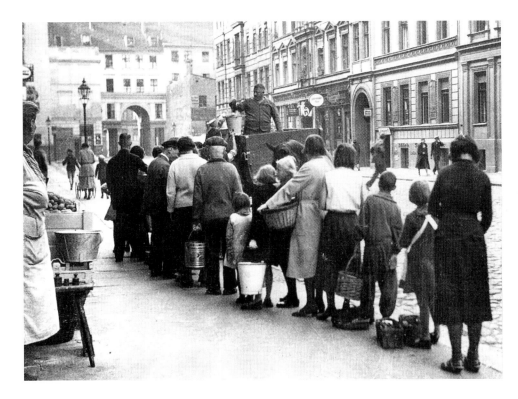

She's just a char, 1924

LEFT:
Berlin, Kreuzberg district, about 1930

A Man of Conviction, 1928

The Best Years of their Lives, about 1923
What makes Grosz's work so vivid is in part his loving attention to detail – such as the exaggerated burst veins in this man's cheek and nose.

grasp the ideas of the proletarians, and to contrast them with the exploiters and oppressors? It ought to be possible! Are you wondering whether it mightn't finally be time to stop producing your mother-of-pearl decorative dainties? You claim to be timeless and to stand beyond the rival parties, but you are merely guarding the 'ivory tower' within yourselves. You claim to be creating for people – but where are the people?!! What is your creative indifference and abstract blather about timelessness but a ridiculous, useless gambit, speculating on eternity? Your brushes and pens, which ought to be weapons, are nothing but straws." Consistently, given his thinking, Grosz's own art was contemporary to the point of being agitprop, and he tried to make it available to as wide a public as possible.

What was known as the "Kunstlump" debate touched on these matters too. During the Kapp Putsch there had been armed confrontations in Dresden between the putschists and the local people. A painting by Rubens in the Zwinger gallery was damaged by a bullet: Oskar Kokoschka, then a professor at the Dresden Academy, appealed to the public to fight out their differences elsewhere, and perhaps even to have the political leaders of the rival sides fight it out in one-to-one combat in the circus – a suggestion which may not have been meant completely seriously. In reply, George Grosz and John Heartfield published an article in "Der Gegner" (The Opponent), titled "Der Kunstlump" (the art scoundrel). Grosz and Heartfield branded Kokoschka as a scoundrel because (they claimed) he rated the art and culture of the bourgeoisie above the lives of the working people. "We are delighted," they wrote, "that the bullets are flying in galleries and palaces, hitting masterpieces by Rubens, rather than in the homes of poor people in working-class districts. If an open struggle between Capital and Labour is fought out on the home ground of disgraceful culture and art, we welcome the fact, because that art has always served to club the poor and to uplift the bourgeois on Sunday so that on Monday he can press on with his skin trade and exploitation in calmness of spirit!" Franz W. Seiwert, a Cologne painter, joined the debate in Pfemfert's "Die Aktion", supporting the Grosz/Heartfield position.

The Communist press attacked not only Kokoschka, though, but also Heartfield and Grosz, whom they accused of vandalism. Heartfield, Grosz and Seiwert were entering a debate which had begun with the Italian Futurists' rejection of conventional bourgeois traditions. The reductio of this position was the demand that art be abandoned in favour of a life of active commitment. This view was expressed by the French Surrealists; by the Russian constructivists, such as Tatlin, Lissitzky and Rodchenko; by the Bauhaus group; and by the artists of the Dutch movement, De Stijl. Ultimately, as critic Werner Hofmann has put it, what was at stake was "the interpenetration of different genres, total expansion, and an integral appropriation of the real".

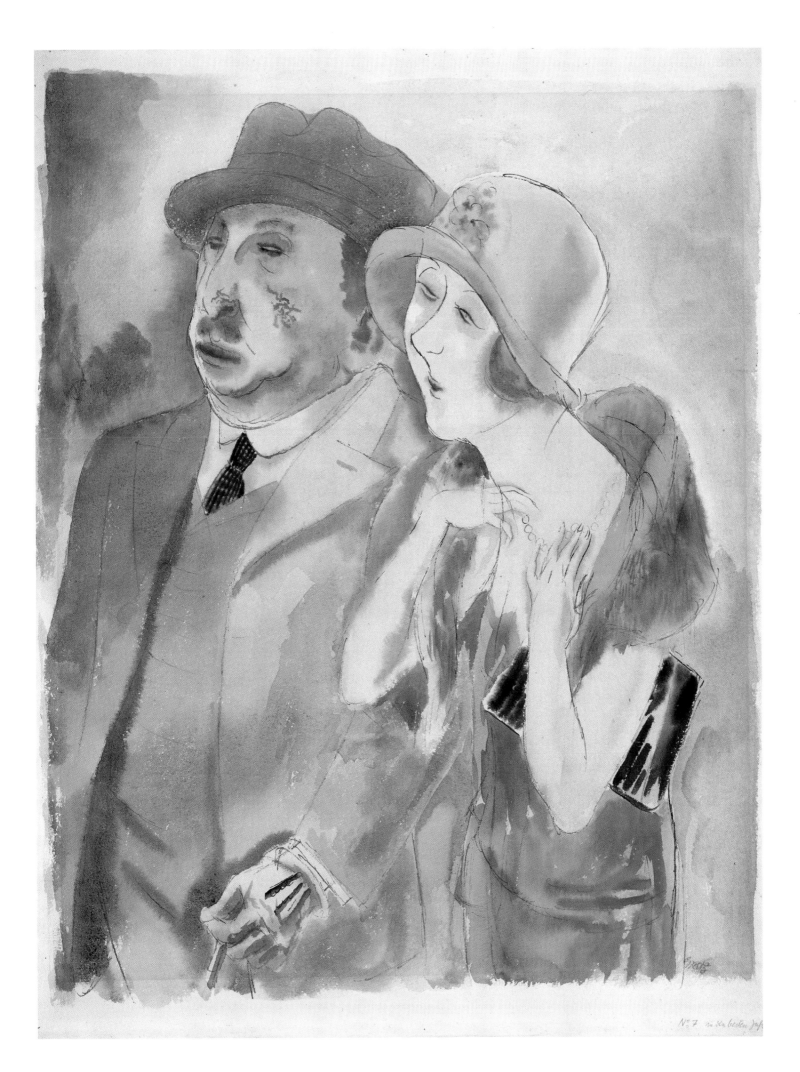

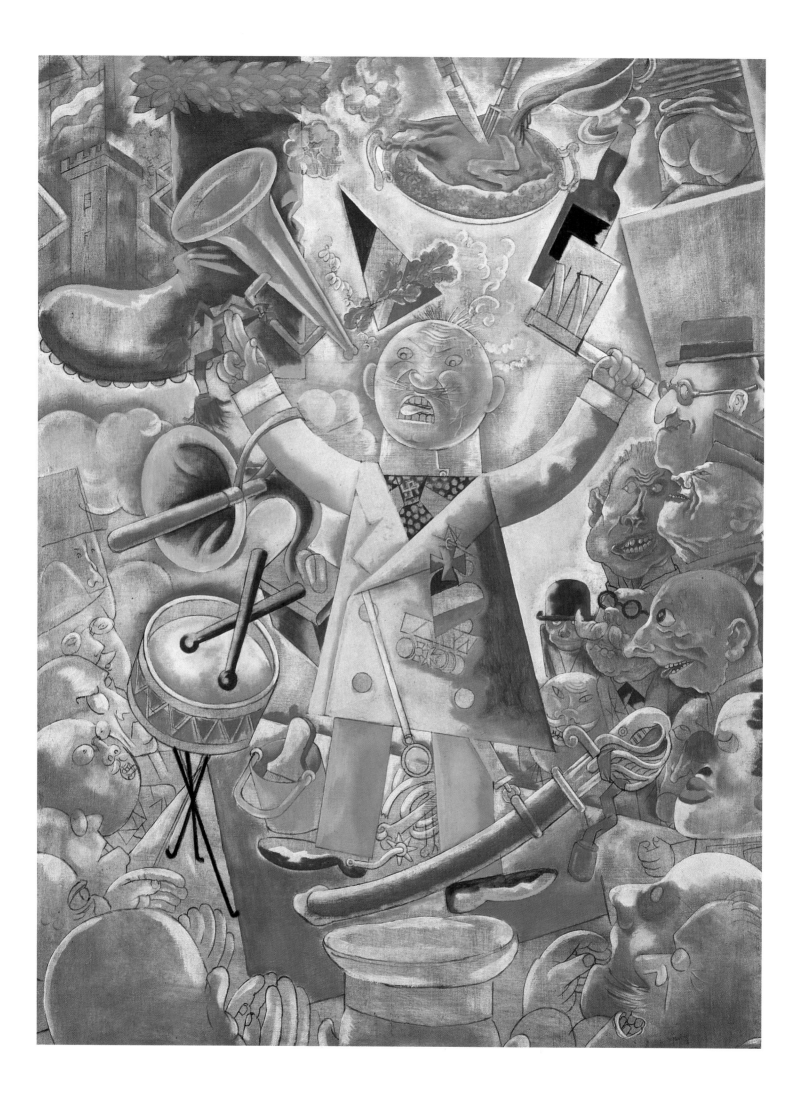

Critical Realism and Disillusionment

To see the 1920s simply as the Roaring Twenties would be a simplistic reduction. Grosz himself characterized the times in these words: "Everywhere, hymns of hatred were struck up. Everyone was hated: the Jews, the capitalists, the Junkers, the Communists, the army, the property owners, the workers, the unemployed, the black Reichswehr, the control commissions, the politicians, the department stores, and the Jews again. It was an orgy of incitement, and the republic itself was a weak thing, scarcely perceptible. […] It was a completely negative world, topped with colourful froth that many imagined to be the true, happy Germany before the onset of the new barbarism." (YN p. 143)

The NSDAP (i.e. the National Socialist party, the Nazis) was founded in Munich in 1920. The SA ("Sturmabteilung" – storm-troopers) followed in 1921, with the aim of terrorizing political opponents. In 1922 Walter Rathenau, the foreign minister, was assassinated; Rathenau's policy had been to show the Allies that Germany could not possibly meet their reparations demands, while at the same time stressing German goodwill – a position that only fuelled the right wing. What was more, Rathenau was a Jew. His murder was planned by nationalist ex-naval officers and free corps members, and continued the assault on democracy that had begun with the killings of Luxemburg, Liebknecht and Kurt Eisner. Politically motivated murder had become a routine thing, and the free corps in particular saw it as a proper and honourable weapon in the political struggle. Grosz and other artists protested in public against the assassination of Rathenau. That same year, Mussolini came to power in Italy, while in the USSR Stalin was elected Secretary of the Communist Party.

One consequence of the failure of Rathenau's strategy was massive inflation, which peaked in 1923. Wage-earners had to spend the contents of their pay packets immediately, since the money would be worth only a fraction as much within hours. For German industry, though, inflation was to be encouraged since it offered a prospect of recovery. There were overnight success stories, and profiteers such as Hugo Stinnes were savagely attacked in "Die Pleite". Grosz contributed a two-page spread of drawings to the magazine, under the title *How to get rich* (p. 62), in which Stinnes appeared in the picture second from right on the bottom row, captioned "Support the dollar and loan money to the government".

1923 also saw the occupation of the Ruhr by French and Belgian troops, following German failure to pay reparations. This placed not only the ore re-

Grosz with *The Agitator*, 1928

The Agitator, 1928
The agitator is a version of Hitler, against whom Grosz warned tirelessly. He is promising the masses that their material needs will be satisfied – but his promise implies rubber truncheons, jackboots and swastikas too.

Animateuses and prostitutes, often past their best, were among the preferred sitters of '20s realist painters. They exaggerated in order to put the naked facts across with utmost force.

sources of Lorraine but also the coal of the Ruhr in French hands. The Germans responded with passive resistance, and occasional right-wing sabotage aimed at French installations. One saboteur, Albert Leo Schlageter, a former free corps member and now a Nazi, was shot, and promptly became a martyr in the eyes of many, from the right wing to the Communists.

German revolutionary hopes revived briefly when regional coalition governments of the SPD and Communists were formed in Saxony and Thuringia. The right, at about the same time, produced Hitler's unsuccessful Beer Hall putsch of 1923. Hitler was given a prison sentence on 1 April 1924 and released on 20 December that year, having written "Mein Kampf" during captivity.

In a word, the times were troubled. In his autobiography, Grosz tells of the revolutionary veteran Max Hölz. In terms as fatalistic as usually prevail in his book, Grosz wrote that Hölz had reminded him "of those fearless Robin Hoods we read of in our childhood. [...] Like them he was a friend to the oppressed, an enemy of tyrants, and a darling with the ladies." (YN p. 150) Following his involvement in a 1921 revolt, Hölz, who expected a death sentence and delivered the appropriate fiery speech accordingly, was sent to prison, where he promptly became a figure of myth. Once released, he became a society figure, dining out on his revolutionary past till he gradually faded into obscurity. Grosz's retrospective description of the man burlesqued the political commitment and turmoil of the times; but in fact Grosz himself was still in sympathy with the Spartacists at that point, as his position in the "Kunstlump" debate shows.

In summer 1922, Grosz travelled with the writer Martin Andersen-Nexø

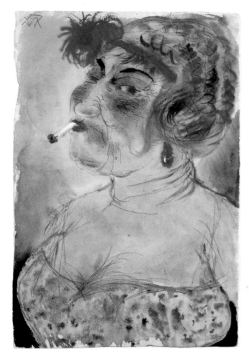

TOP:
Otto Griebel: ***The Naked Whore,*** 1923

BOTTOM:
Otto Dix: ***Brothel Madame,*** about 1923

RIGHT:
Streetwalking, 1922

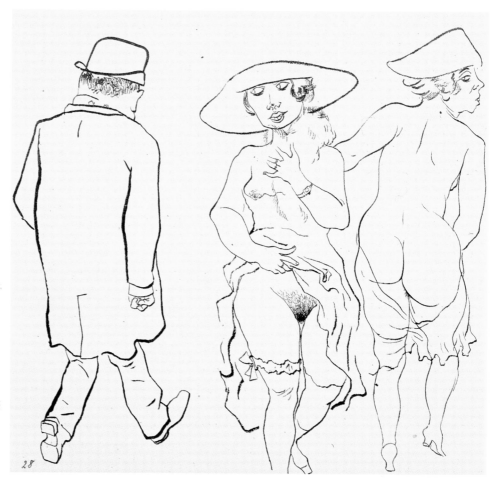

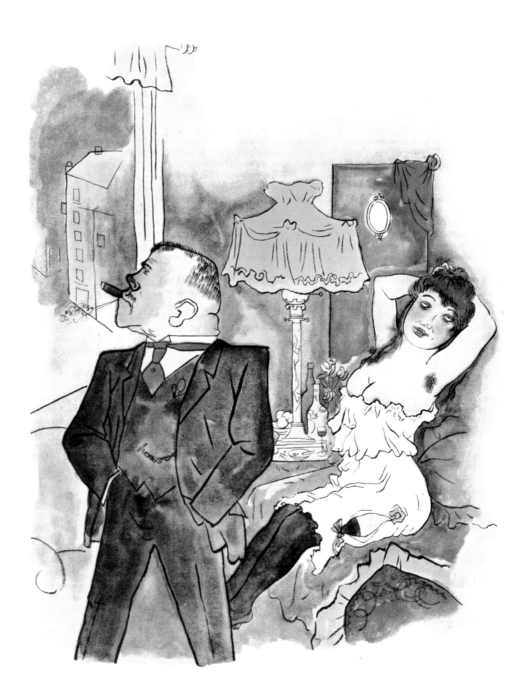

Strength and Grace, 1922
Grosz's titles often contrast with his content
to create tension and wit. Here he is bur-
lesquing traditional gender roles as well as
bourgeois double standards in morality.

to Russia. Nexø was to write a book about Russia and Grosz to supply the il-
lustrations. The trip was to have gone like clockwork, but in the event they
encountered an endless succession of obstacles. They waited in vain for the
ship that was to have taken them from Denmark to Russia; and when, at last,
they managed to arrange their own passage to Murmansk, they were arrested
as spies on arrival. Once their papers were approved, Grosz met Comintern
secretary-general Gregori Zinoviev; Tatlin, a co-founder of Russian construc-
tivism; and even Lenin, who seems to have been familiar with George
Grosz's album "Das Gesicht der herrschenden Klasse" and to have had a
high opinion of it. Grosz was received by the Russian Communist Party's
German expert, Karl Radek, and travelled from Moscow to Leningrad with
Lunacharsky, then Commissar for the Arts and Education. "My journey had
not been a success. […] I was neither disappointed nor particularly pleased
by what I had seen. The mote that was in my eye at that time when I ob-
served western capitalist countries remained in my eye in Russia." (YN
p. 176) Since Grosz did meet people of high rank in Russia, it seems fair to

"Offences against public morality" – Grosz and the Law

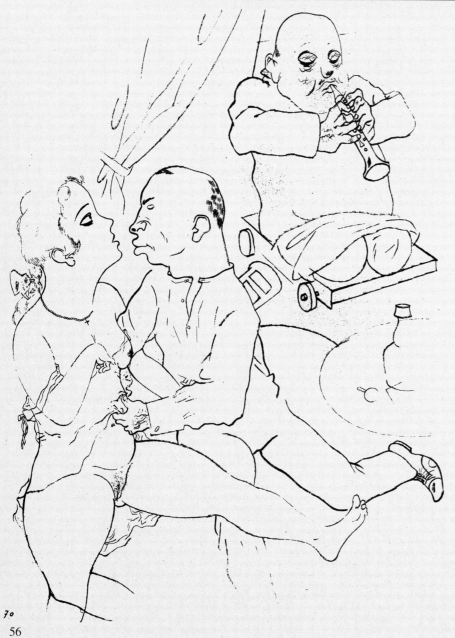

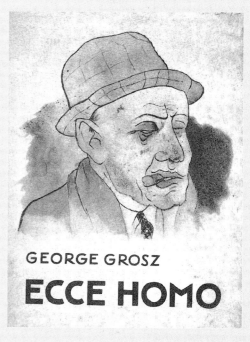

GEORGE GROSZ
ECCE HOMO

TOP LEFT:
Grosz, Wieland Herzfelde and defence counsel Apfel at the blasphemy trial, 1929

BOTTOM RIGHT:
Cover of the "Ecce Homo" album, 1922

BOTTOM LEFT:
Serenade, 1922

ILLUSTRATION PAGE 57:
Cross-section, 1919/20

Publication of the "Ecce Homo" album brought Grosz a fine for offending public morality in 1924. His barbed pen had touched middle-class society on a nerve.

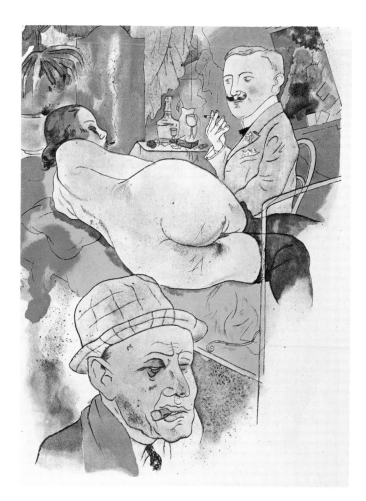 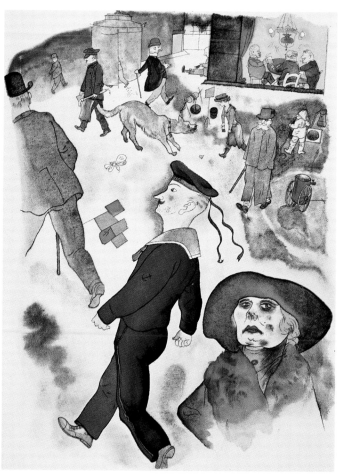

LEFT:
Ecce Homo, 1921

RIGHT:
Passers-by, 1921

assume that his fame had spread. Though his experience of the country may have had a sobering effect on him, it did not change his fundamental political stance.

The motivation behind Grosz's art has been identified time and again as hatred; but we are insufficient in our response if we narrow him down to that alone. Nor are his paintings and drawings illustrations of party political doctrine. He was using a (now unfashionable) dialectic approach to visual representation, an approach which was also apocalyptic and not without compassion. His ostentatious misanthropy had its share of humanist idealism, and this in turn was not without moral dimensions. And in all things he hankered after independence.

It remains the case, though, that in the 1920s Grosz was a political animal, joining in protests. "Wherever non-party protests were made against injustice in the Twenties, Grosz was sure to be there." One such involvement was with International Workers' Aid, established in 1921 by Willi Münzenberg, then head of Communist Youth International and subsequently the founder (in 1925) of a workers' newspaper, the "Arbeiter Illustrierte Zeitung", which was made famous by John Heartfield's political photomontages. International Workers' Aid was a response to failed harvests and starvation in Russia, and its committee members included, along with Grosz, Albert Einstein and George Bernard Shaw.

In 1923 Grosz stopped paying his Communist Party membership dues. Nonetheless, in 1924 he became chairman of the "Rote Gruppe" (Red Group), an artists' association with John Heartfield as secretary and Rudolf

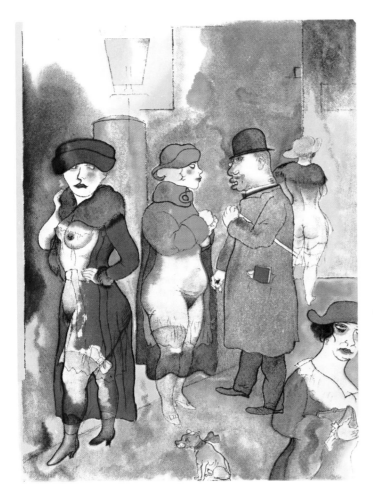

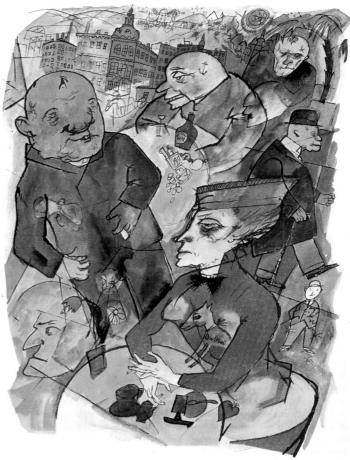

Schlichter as chronicler. Among the group's members were Otto Dix, Otto Nagel and Otto Griebel. Their programme demanded that one and all, artists included, place their abilities at the disposal of the class struggle. It called for "practical assistance on all revolutionary occasions" as well as "opposition to the ideological remnants of 'heimat' romanticism in proletarian environments". Little is known of what the "Rote Gruppe" actually did, and in 1928 it was absorbed into the "Association Revolutionärer Bildender Künstler Deutschlands" (German Association of Revolutionary Artists), with which Grosz had no substantial connection.

In 1924 Grosz again faced prosecution, this time for offences against public morality and for besmirching the values of the German people. His album "Ecce Homo" was the occasion of these charges. Writer Max Herrmann-Neisse, whose portrait Grosz twice painted (see for example p. 69), wrote of the album: "When you open it, you have before you the quintessence of what is currently all about you: the type of persons who affect to govern you; the stupidity of the underlings who make this rule possible; the infinite crumminess of your own middle class background; the witless, unreal filth of eroticism, to which you owe your own existence (which would best not have happened at all) and to which you will yourself soon fall prey again. It is a full and comprehensive object lesson, a panoramic view of life, at once art and historical document, a chronicle and not an entertainment." The album was confiscated as being pornographic; 24 of the 100 plates were also confiscated; and Grosz was fined 6,000 marks. Grosz's lack of eloquence told against him at the trial. He

LEFT:
Before Sunrise, 1922

RIGHT:
Ah crazy world, you wonderful freakshow, 1916

In contrast to his earlier stance, in "Ecce Homo" Grosz was attacking middle-class private life. He exposed erotic dissipation and the secrets hidden behind prim and proper façades in order to maintain public morality.

ILLUSTRATION PAGE 60:
The White Slaver, 1918

ILLUSTRATION PAGE 61:
Beauty, thee will I praise, 1919

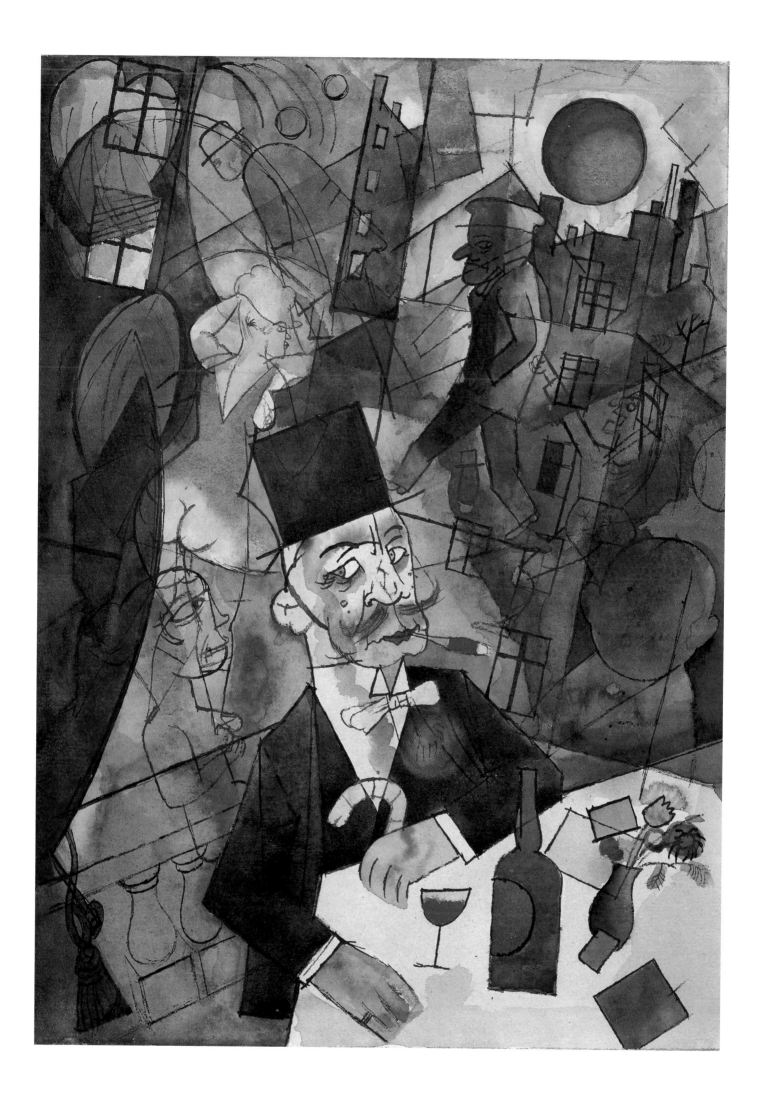

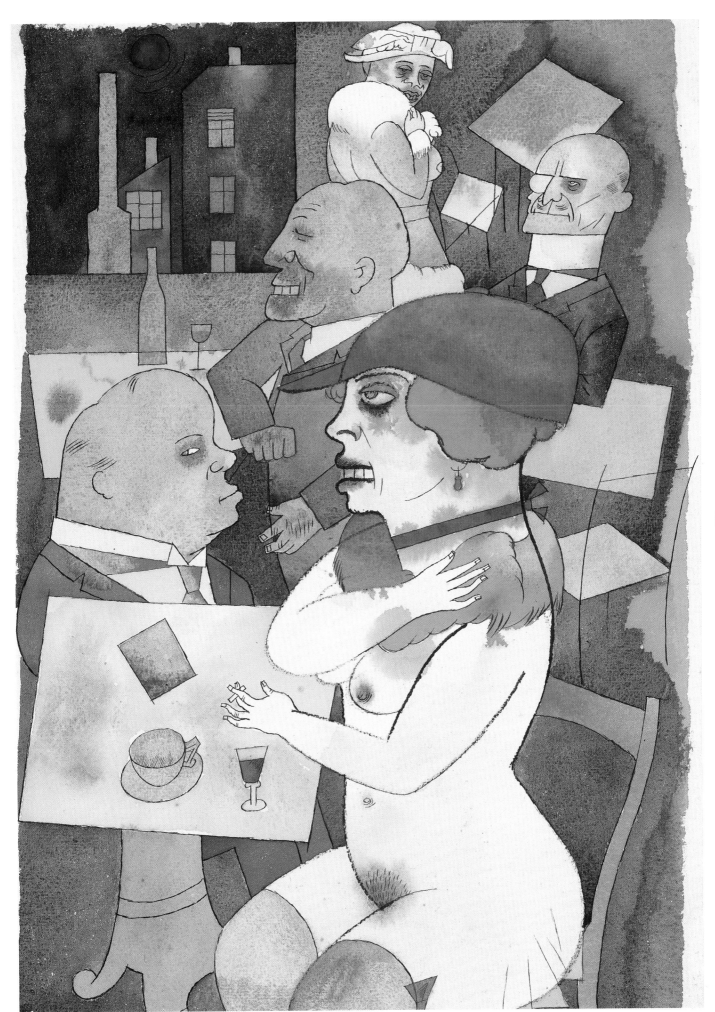

Wie werde ich reich?

Translation of the undertitles of the
drawings (top to bottom):

Marry the right woman

Become a filmstar

Win battles, loose wars, write
your memoirs, and invest in silver
dollars and pounds

Become a fascist and speculate on
progroms to acquire Jewish property

Collect cigar butts

Start a sports lottery

Become a separatist and the frank
will drop into your pocket of its
own accord

Go into politics

Be a middleman

Get elected into parliament

Support the dollar and loan to the
government

But never through work!

Wähle die richtige Frau

Werde Filmstar

Gewinne Schlachten, verliere Kriege, schreibe
Memoiren und versilbere sie in Dollar
und Pfund

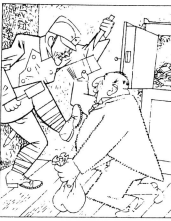

Werde Faschist, spekuliere auf Pogrome und
sammle die jüdischen Reichtümer

Sammle Zigarrenstummel

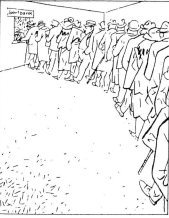

Gründe eine Sportbank

Werde Separatist, dann rollt der Frank von
selbst in deine Tasche

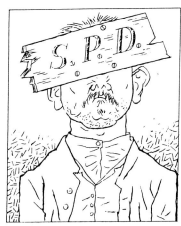

Mache in politischer Karriere

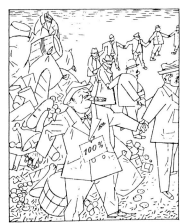

Werde Zwischenhändler

Laß Dich ins Parlament wählen

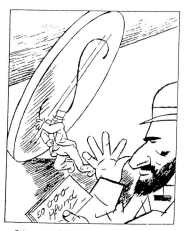

Stütze den Dollar und laß Dich von der
Regierung anpumpen.

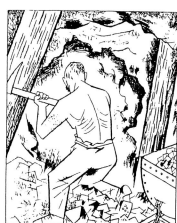

Durch Arbeit nie!

ILLUSTRATION PAGE 62:
How to get rich, panel sequence from
"Die Pleite" magazine, 1923

BOTTOM:
Soirée, 1922
In his autobiography, Grosz likened people at
official receptions to insects: "The ladies'
dresses are like the iridescent wings of
beetles, the men's dinner suits like dark dung
beetles. And how insect-like is their omni-
vorous greed at the ample buffets!"

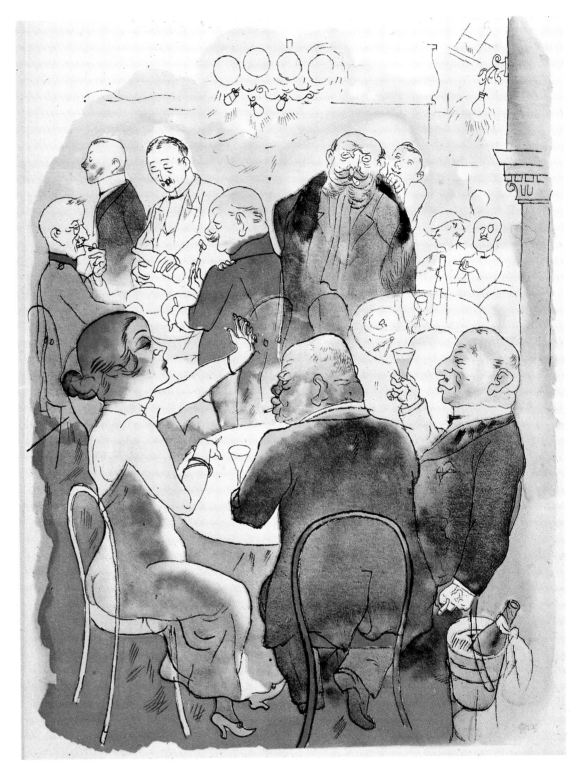

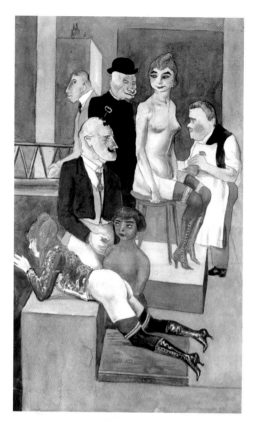

Rudolf Schlichter:
A Meeting of Fetishists and Manic Flagellants, about 1923

Rudi S., 1921
The painter Rudolf Schlichter, burlesqued here, was a fetishist who openly proclaimed his love of long lace boots and expressed it in his paintings. Grosz kept his own pornographic watercolours of the period secret.

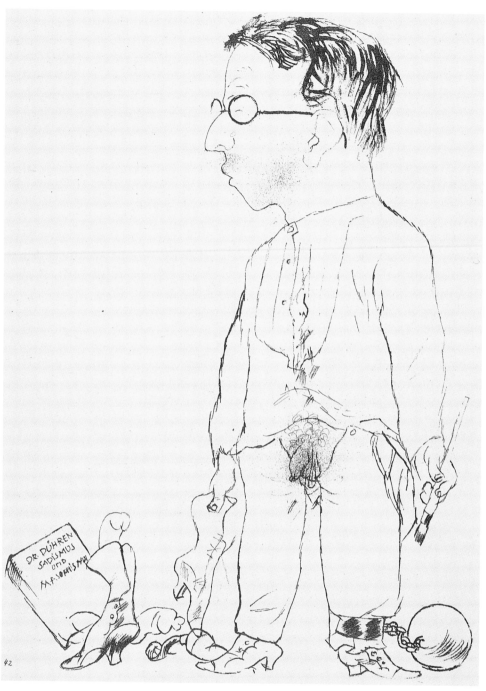

faltered his way through a piecemeal argument. Even so, the affair helped consolidate his fame.

Grosz's first solo exhibition had been arranged by Hans Goltz in Munich in 1920, and in 1923 he was signed up by Alfred Flechtheim in Berlin. Flechtheim had helped make modern French art known in Germany through exhibitions, and under his influence Grosz's ideas on art underwent a change. He began to hedge his bets. In 1927, writing from the South of France, he told his brother-in-law Otto Schmalhausen: "My plan (naturally this is what Flechtheim's speculation is based on) is to paint a series of saleable landscapes here

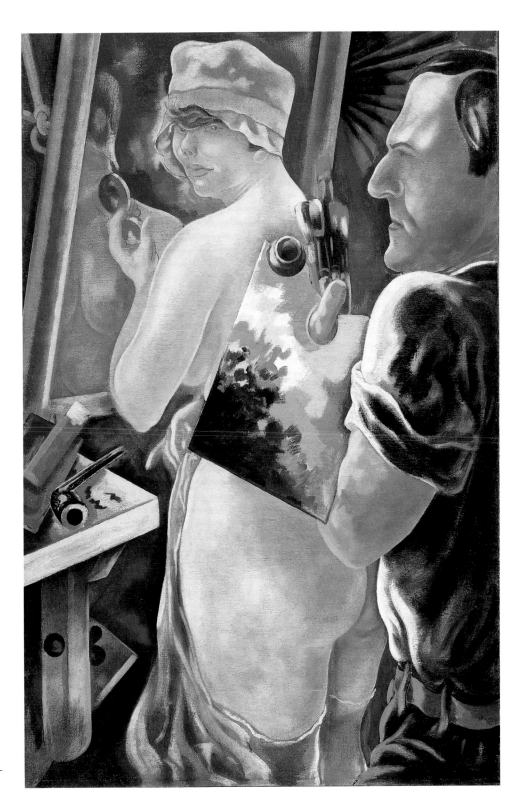

Artist and Model, 1928
The painter is Grosz and the model his wife
Eva. His use of the traditional theme suggests
that Grosz was trying to locate a feasible artis-
tic option for himself.

– that is, without objectionable subject matter. If I sell them, this winter I shall
tackle big paintings of the kind I prefer doing, such as *Eclipse of the Sun*
(p. 40) or *The Pillars of Society* (p. 73). Courbet did the same, painting Lake
Geneva over and over for people who could pay." Grosz was still working for
various Communist publications, but also for Flechtheim's magazine "Der
Querschnitt", contributing material both visual and written.

In 1924 the political situation quietened somewhat. The great inflation
was over, the currency stable once more, and a mainstream government had
been established with the Social Democrats' parliamentary support. The elec-

tions of May 1924 returned 32 members of the extreme right, ten of them supporters of Hitler, while the Communists won 62 seats. This was the Stresemann era: Gustav Stresemann had been Chancellor for some months in 1923 before becoming foreign minister, a post he held till his death in 1929. It was under his guidance that Germany joined the ill-omened League of Nations in 1926.

Grosz's book "Der Spießer-Spiegel" was published in 1925. Compared with "Ecce Homo", where the exaggerated caricature mode served the harsh purposes of denunciation, the new publication seemed reticent (cf. p. 42). Grosz was drawing things as they were. Street scenes in which people passed each other by without so much as registering each other's presence perhaps pointed to an element of resignation in Grosz's work. The faces of his people were still mildly deformed, but whereas the reasons for the distortion were apparent in his earlier work, articulated through action or qualities of the visual space, they are now no longer clear.

Grosz's commitment to the class struggle was gone. His book "Die Kunst ist in Gefahr" (Art is in Danger), though, co-authored with Wieland Herzfelde, seems to tell a different story. In it, artists are repeatedly called upon to place their services at the disposal of the revolution. In writings such as this, and in various paintings and drawings of the later Twenties, we may well detect a conflict being fought out within Grosz himself. Passivity, and the withdrawal from public commitment, were phenomena he could observe all around him. In the early years of the Weimar Republic, no successful attempt had been made to establish democratic principles and guidelines at every level; and the constant battles fought out during the decade, and the repeated changes of government thanks to failures in securing strong majorities, had left most people apathetic.

One term became established and seemed to catch the keynote of the period: "Sachlichkeit" (objectivity or sobriety). In 1925 Gustav Friedrich

TOP:
Grosz with his model for *Max Schmeling,* 1926

ILLUSTRATION PAGE 67:
Max Schmeling the Boxer, 1926

BOTTOM:
Bertolt Brecht and boxer Samson-Körner, 1928

Boxing was popular among artists and intellectuals. Grosz had taken lessons, and his friend Brecht co-authored a short story, "Hook to the Chin", with middleweight champion Paul Samson-Körner.

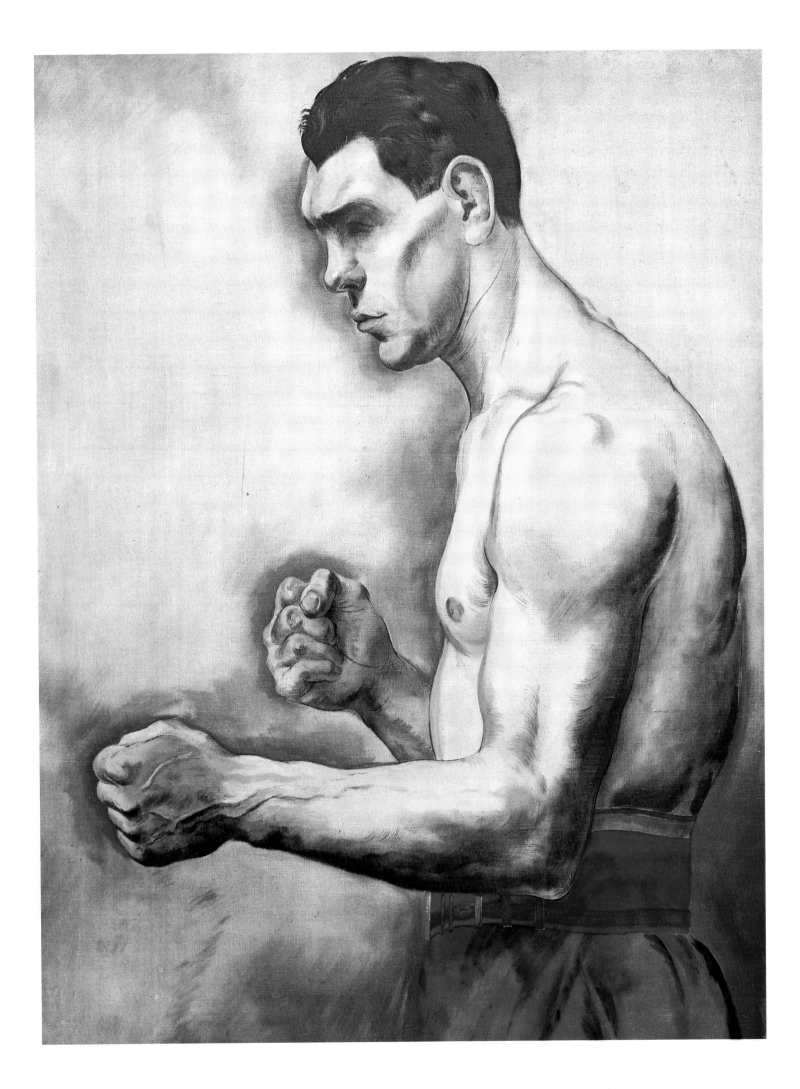

Portrait of the Writer Walter Mehring, 1925
In his autobiography, Grosz described his
author friend as "a François Villon of the
Spree, with a touch of Heinrich Heine". Meh-
ring recited poems and sang on the stages of
Friedrich Holländer, Max Reinhardt and
Erwin Piscator. His song "Hoppla, wir leben!"
was a great success.

Hartlaub curated an exhibition at the Mannheim art gallery titled "Neue
Sachlichkeit: Deutsche Malerei seit dem Expressionismus" (New Objectiv-
ity: German Painting since Expressionism).

The term "Sachlichkeit" was misleading in so far as various kinds of art
were included in the show, which was based on a survey run in 1922 by the
magazine "Das Kunstblatt" on the question, "A new naturalism?". In that
context, Hartlaub had distinguished conservative/classicist art from a lurid
wing born of the denial of art. Subsequently the artists of the former group,
among them Alexander Kanoldt, Georg Schrimpf and Anton Räderscheidt,
were dubbed "magical realists" or "idyllicists" (Franz Roh's term), while
those of the latter were called "Verists". This latter group included Grosz,
Otto Dix, Rudolf Schlichter and others. The roots of the Verists lay mainly
in Dadaism.

From 1925, Grosz returned to painting in oils. He did a number of portraits, as well as pictures that carried on where *Germany: a Winter's Tale* (p. 33) had left off. His *Portrait of the Writer Max Herrmann-Neisse* (p. 69) is a good example of Verist art. To Count Harry Kessler, Grosz remarked that the picture was his first painting experiment for a long time, which was why it had turned out rather dry. The artist and his model had been acquainted since 1917. Herrmann-Neisse wrote for "Die Aktion", "Der Gegner", "Der blutige Ernst" and other magazines. In 1923, in "Die Aktion", he had said of Grosz: "he sees things as one is not supposed to see them in bourgeois Germany: as they are, not as they seem!" And so the painting shows the writer as he was, and as numerous photographs show him to have been. Grosz posed the short, thin man, bald and hunchbacked, in a floral-pattern armchair which offered a notable contrast to the sitter's dark suit. The writer is tense, his legs crossed and his left hand clasping the arm-rest, a large ring on his little finger seeming to emphasize the gesture. The setting is only sketchily defined; Herrmann-Neisse is sitting on a dais, head held erect, gazing through metal-rimmed glasses at or past something we cannot see. His introspective gaze contrasts with the man-about-town air of his three-piece suit and gaiters, which in turn only serve to stress his stunted physique.

Few of Grosz's other portraits of this period are so exact in their characterisation. The portraits of writer Walter Mehring (p. 68) and art historian Eduard Plietzsch (p. 69), for instance, are almost stereotypical in their construction, showing the sitters in armchairs with cigarettes in their raised right hands.

Portrait of Dr. Eduard Plietzsch, 1928

Portrait of the Writer Max Herrmann-Neisse, 1925
Like art historian Eduard Plietzsch, the writer Max Herrmann-Neisse was one of Grosz's friends. He painted his portrait more than once, and described their relations thus: "…we came from very similar backgrounds, we both liked to drink kirsch, though we did not speak the same dialect we talked the same language, we were both poets and cynics, proper people but anarchic!"

Grosz made further biting comments on the times in *The Pillars of Society* (p. 73) and *Eclipse of the Sun* (p. 40), both painted in 1926. The former painting returned to subject matter already addressed in *Germany: a Winter's Tale*. The first of the pillars in question is the German nationalist with his monocle, the fraternity scars on his face, a swastika pinned to his tie, holding a sabre and a beer mug. The top of his head has been lifted off to reveal a cavalryman with the black-white-and-red national colours on his lance. Vaporous paragraph symbols suggest bureaucratic preoccupations too. Second of the pillars is the journalist, with moustache and pince-nez, newspapers clutched beneath his arm, a pencil in one hand and in the other a palm leaf, and an upturned chamber-pot on his head. Third of the trio is the social democrat, with his slogan "Socialism is labour" – he too with the national

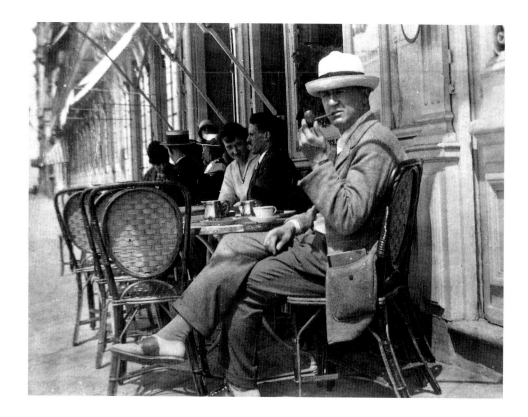

colours, and with excrement steaming in his head. His facial features bear a similarity to Ebert's. Behind this threesome, other pillars of society are at work – the intense priest, the brutal soldiery – while in the background the city is already in flames.

Grosz at the Café de la Plage, Boulogne-sur-Mer, about 1927

In *Eclipse of the Sun* (p. 40), which critic Hans Hess has seen as "allegorical realism", the military and economic leaders (with the Church represented symbolically by the cross on the table) are dictating what must be done to a headless gathering of politicians. The sun has been eclipsed by a dollar sign; and, at bottom right, death waits.

In *Self-Portrait, Warning* (p. 75), painted in 1927, Grosz appears as the moralist with raised, admonitory finger. It is as if he were beginning to lose his faith in the effectiveness of art in producing social change. One year later Grosz painted another self-portrait showing himself in hat and scarf, wearing a tie and jacket, and with his pipe in his hand. The hat seems

somewhat too big for him, sitting well-nigh on the bridge of his nose. His gaze is sceptical, and of the admonitory stance nothing remains. At first glance, this later self-portrait seems neutral in tenor; but it records scepticism, the suspension of judgement on a future Grosz had amply expressed his fears of in his earlier work. In other words, in 1928 he was considering his position as a committed artist – in the very year when the SPD, for the first time in many years, became the party of government with Hermann Müller as Chancellor.

Another 1928 painting was *The Agitator* (p.52). The usual assembly of overdrawn grotesques are cheering a gross character who presumably stands for Hitler. This character has a rattle in his left hand, and by his right a trumpet, with an outsize soldier's boot in the background. He has a swastika, a German nationalist heart and hat, and a rubber truncheon slung over his arm. What he is promising is indicated at the top of the picture: plenty to eat and

Pointe Rouge Landscape near Marseilles, 1927
Away from the city's bustle and political turmoil, Grosz painted the south of France in harmonious colours. To his dealer, Flechtheim, he wrote that he was planning a series of "saleable landscapes".

Maul halten und weiter dienen

drink – in a word, prosperity – with the luxuries of pleasure added (symbolized by the bare female behind). Grosz was putting the phrases of the time into visual form.

"Hitherto," historian Helmut Heiber has observed (i.e. up to 1929), "Adolf Hitler had been a negligible factor in German politics, a Bavarian beer-hall hero, one of the many and generally ludicrous folk figures who try to bring their political broth to the boil on a little wood fire. But now his rise into the politics of the Reich was beginning, and things were to develop so favourably for him that within a very few years he was to be at the very top." Despite Count Harry Kessler's opinion that Grosz's thinking was intellectually rudimentary, the artist nonetheless possessed a clear view of what was set to happen on the political scene. But his warnings mostly went unheard or unheeded.

Throughout the 1920s, Grosz did a considerable amount of work for the theatre. He designed stage sets, and as early as 1920 he designed puppets for a political puppet show at Max Reinhardt's "Schall und Rauch" cabaret. Since then, he had worked for Berlin theatres at least once a year, designing sets or costumes or both, initially collaborating with John Heartfield. In 1927, Erwin Piscator commissioned Grosz to design the set for a dramatization of Hasek's "The Good Soldier Schwejk". Piscator staged the play on two moving conveyor belts, and Grosz designed cardboard figures and objects to be conveyed across the stage on the belts, as well as a cartoon film for background projection.

In 1928 Malik, Grosz's usual house, published a portfolio of 17 selected gravure prints in a run of 10,000, titled "Hintergrund" (Background). Grosz was anonymously denounced to the police, and as a result three drawings from the album were confiscated and the artist charged with blasphemy. The

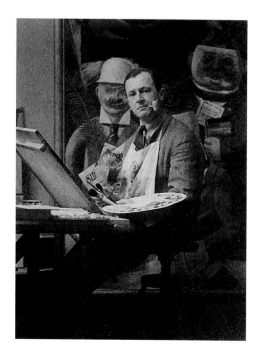

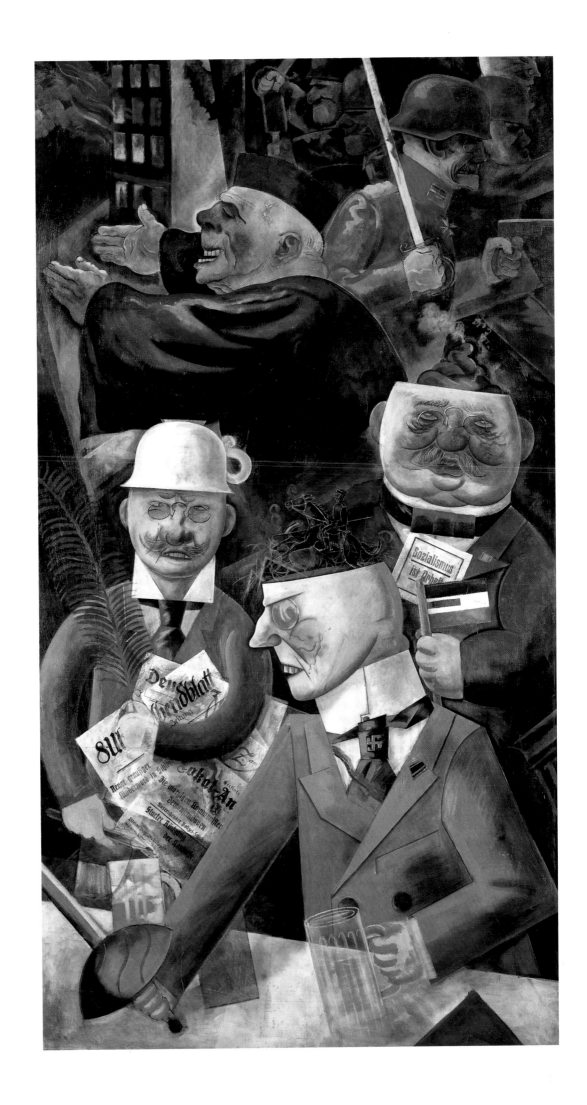

most famous of these three is Christ wearing a gas mask, captioned *Shut up and keep serving the cause* (p. 72), while another that incurred disfavour showed a priest showering grenades from the pulpit and was titled *Distributing the Holy Spirit*. The trial lasted three years, went through a number of appeals, and became the most important blasphemy case to date. The witnesses took highly divergent positions: while Edwin Redslob, representing public art policy, was vehemently on Grosz's side, as were other experts called by the defence (among them Count Harry Kessler and the head of the Quakers in Germany), the Catholic church held that the religious sensibilities of all had been profoundly insulted. In the end, Grosz was acquitted, but the verdict did include punitive measures: "Drawing no. 10 in the album 'Background', published by Malik, and every copy of this drawing in the possession of the artist, printer, publisher or dealer, including copies displayed or offered for sale in public, as well as the plates used for production of the drawing, are to be destroyed." Wieland Herzfelde, however, had already sold off sealed cratefuls of the work, which earned him another charge; while the plates, the powers that be were told, had already been erased after printing.

TOP:
Hitler the Saviour, 1923

CENTRE:
The Tree of Life, Phases 2 and 3, 1927

BOTTOM:
Why?, 1928

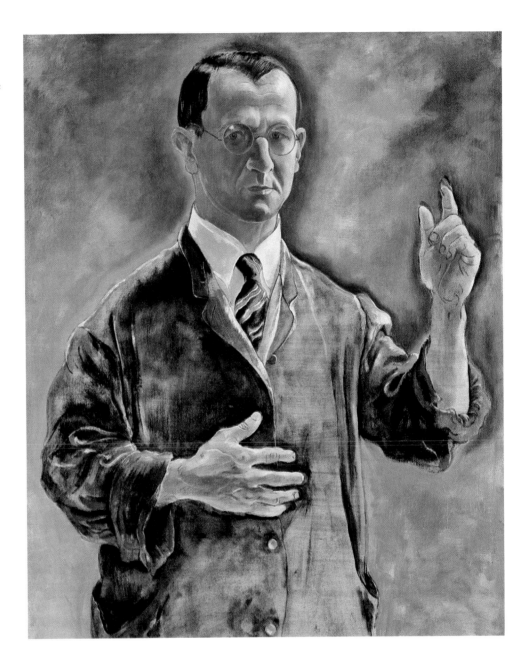

Self-Portrait, Warning, 1927
Grosz never tired of warning against Hitler, whom many of his contemporaries did not consider a danger. This self-portrait marks the onset of resignation. "I realised that people simply took no notice of my drawings. My warning had been spoken into the wind."

The trial attracted great public interest. Artists and intellectuals protested against the attempt at censorship, among them Grosz's writer friends Kurt Tucholsky and Walter Mehring, and Carl von Ossietzky, later winner of the Nobel Peace Prize. The last recorded transaction in the case was dated 17 October 1933, when Goebbels' Propaganda Ministry requested the director of public prosecutions to supply a copy of the drawing in question "for a pamphlet which is to deal with cultural bolshevism, among other matters."

Dream and Reality

In 1928 a pamphlet by Paul Schultze-Naumburg was published in Germany. Its title was "Kunst und Rasse" (Art and Race). The following year, Alfred Rosenberg, Heinrich Himmler and other Nazis established the "Kampfbund für deutsche Kultur" (Combat League for German Culture). Wilhelm Frick, a Nazi and minister of the interior in Thuringia, whose brief included "education of the people", issued a set of "Verfügung gegen die Negerkultur" (Guidelines against Negro Culture) in 1930. Shortly after, the Nazis took a further 95 seats in the Reichstag election of that September, becoming the second strongest party after the SPD. Repressive measures against left-wing or independent artists and intellectuals were increasing, and so too, in response, was the exodus: Kurt Tucholsky, Herwarth Walden, Georg Lukács and Carl Einstein emigrated even before Hitler came to power, and many more, such as Thomas Mann and Bertolt Brecht, followed when he did so.

In 1931 George Grosz had the good fortune to be invited to New York by the Art Students League, to teach there in summer 1932. For Grosz, it was a boyhood dream come true. In his description of the expectations he had, though, irony is as ever the keynote: "You heard the craziest tales of America. They said there were plums there as big as your palm, grown so they opened of their own accord when you said the magic word and spat out their stones themselves." (YN p. 219) Grosz taught in the summer semester, spending his spare time in the cinema, variety shows, and perhaps the dime museums too, where he could see what Barnum & Bailey had shown him as a child.

A Rev. John Mingen wrote to Grosz (in German) not long after the artist arrived in the US, with a warning: "Beware, Herr Grosz, of hurting the feelings of Christian Americans with your work. Beware the moral judgement of the Christian religions in the USA." There were those in America, he said, who were well aware that the feared satirist and critic George Grosz was heading for their homeland.

But in fact there was no cause for alarm: Grosz, like many an exile, was out of water in his new environment. If we compare the 1915/16 drawing *Memory of New York* (p. 20) with *New York Street* (p. 78), done in 1932 in the city itself, the differences are striking. What had been a vision was now experienced reality. The early drawing drew on the artist's longing for an ideal, or at least for something different. But once the longing was fulfilled, Grosz was not contented; rather, he was pained, and driven to cynicism and what might metaphorically be seen as "a burning of himself".

Mouse in the Trap, 1955

Manhattan, about 1934
Grosz lived in America from 1933 till 1959. His work of these 26 years was extensive, and has yet to be viewed and evaluated in its entirety.

In America, Grosz tried to fit in. He wanted to "adapt properly to the American way of life. I did not want to be like the émigrés I met, some of whom were even proud of their inability to fit in."

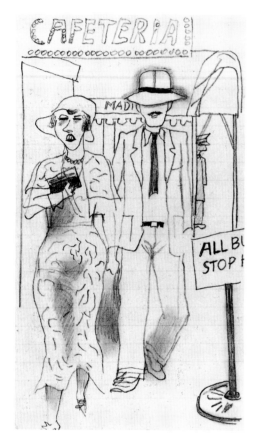

LEFT:
Drawing from the American Sketchbook, 1932

RIGHT:
New York Street, 1932

The New York drawing is a neutral record, with neither analysis nor imagination to fire it.

In October 1932, Grosz returned to Germany, only to embark again with his wife, on 12 January 1933, for his permanent return to America. On 30 January Hitler became Chancellor of Germany. The US, meanwhile, was in the depths of the Depression: "In winter you saw women in furs selling apples in the street, and many a well-dressed person standing in the queues at the Hearst wagons for free bread and soup. But I had seen and drawn worse things, for so many years, and these things therefore did not strike me as particularly abnormal." (YN p. 222)

As well as teaching, Grosz (as in the earliest years of his career) submitted drawings and illustrations to periodicals, but – with the exception of the satirical "Americana" – only with occasional success. A change came

New York Skyline, 1951
"For someone who grew up in Europe, and an artist to boot, this attempt to fit in totally is of course not easy. It takes constant practice if one is to approve of everything wholeheartedly with every day that comes."

upon him, and he began to become an artist in a more conventional sense, studying nature and condemning his own past. "Now more than ever", he wrote in his autobiography, "I see caricature as a minor form of art, and consider the times that produce it to be times of decline. For life and death, if I may be allowed to say it, are great subjects – not to be approached with mockery and cheap jokes." (YN pp. 225–6)

In the context of contemporary American art, Grosz was a homeless figure indeed. John Sloan had urged that Grosz be invited by the Art Students League, but the invitation had occasioned a controversy, whereupon Sloan resigned the chair of the League. Sloan was a member of a loosely affiliated group of artists who dealt with social themes, in the broadest sense; among them were the Mexicans Diego Rivera and Clemente Orozco, and a long-time admirer of Grosz, Ben Shahn. A different current in Ameri-

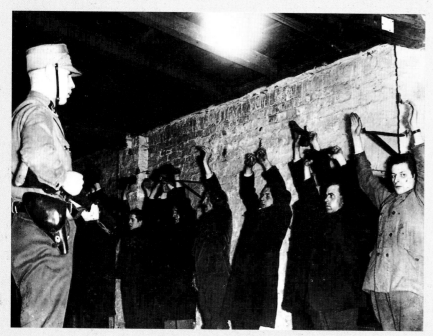

The Powerlessness of the Emigré

TOP:
President von Hindenburg and Chancellor Hitler, 1933

CENTRE:
Torchlit SA procession to Hitler's Chancellery, 1933

BOTTOM:
SA guard with captives, 1933

ILLUSTRATION PAGE 81:
A Writer, eh?, 1935
Grosz was shocked to learn of the terrible death of his friend Erich Mühsam in a concentration camp, and returned briefly to his political drawings in '20s style. In 1936 he assembled an album titled "Interregnum" which demonstrated the brutality of Nazi rule and the powerlessness of the victims.

can art was the regionalism of Thomas Benton (Jackson Pollock's teacher), Grant Wood or Reginald Marsh. And there were critics who tried to define Grosz as an anti-Modernist, and so play him off against the "degenerate" Modernism of a Picasso, Matisse or Brancusi. One critic, Thomas Craven, published a study in 1934, "Modern Art", which was close in tone and tenor to the Nazis who railed against "degenerate art". But modern French art did have a powerful advocate in Alfred H. Barr Jr., director of the Museum of Modern Art.

Grosz drew American character studies and did landscape watercolours. He also returned intermittently to oils. In one watercolour of 1935, *Broadway*, we see a residue of his former style; but there is a difference. The distance he always established, as if he were viewing events from a position above everything, is a thing of the past, and now he presents city life as a participant, from the ant's rather than the bird's eye view.

Grosz taught at the Art Students League till 1936. Till 1937 he also taught at the Sterne Grosz School, which he had taken over and where his students

Cain, or, Hitler in Hell, 1944
In the 1940s Grosz painted a number of apocalyptic pictures which expressed his powerlessness and despair at developments he had always warned of – in vain.

in painting and drawing were mainly society ladies. His success in selling work, or placing illustrations with magazines, was virtually nil, though he did illustrate a collection of O'Henry short stories. Of these 21 watercolours, six were later included as coloured phototypes in the album "Baghdad on the Subway" (the title being O'Henry's name for New York at the turn of the century). From 1937 to 1939, Grosz was the recipient of a Guggenheim fellowship, which enabled him to devote time to his own work. Generally speaking, he was not badly off in America, able to afford a house and a maid: he was not rich, but he got by comfortably. In 1935 he visited Europe, travelling to Paris and to Denmark to see his friend Bertolt Brecht, who was soon to emigrate to the US too. Grosz returned to New York via Holland, where he visited a friend of his student days, Herbert Fiedler.

In America, Grosz tried to fit in. He wanted to "adapt properly to the American way of life. I did not want to be like the émigrés I met, some of whom were even proud of their inability to fit in." (YN p. 232) He tried to become an American illustrator. There were two difficulties in this. On the

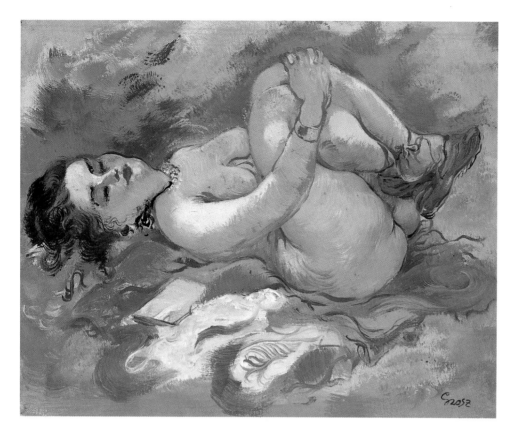

Nude, 1938

one hand, there was a yawning gap between the fictional land of Leather-stocking and the American Dream, and the more sober reality. On the other hand, Grosz had in any case never been an illustrator. He did not take easily to the work, and, although he supplied little drawings to "Esquire" for two years, he complained that he could not match the simplicity and ease he so admired in American illustrations. In his watercolours, he lamented, the paint simply spread where it shouldn't. This was perhaps modesty: if we consider his watercolours of the period, the paint in fact often runs into wet surfaces in an aggressive, barbed way, as if it were corroding the very outlines of the subjects.

In 1934 Grosz learnt that his friend Erich Mühsam had died in a concentration camp, and his old fury broke loose, to be expressed in an album titled "Interregnum", published in 1936 by Black Sun Press with a foreword by John Dos Passos. The album contained 60 photolithographs after drawings dating mainly from 1924 to 1936, among them *Remember* (p. 30), which he had originally done probably as early as 1919, to commemorate the killing of Rosa Luxemburg and Karl Liebknecht. The album eloquently revealed Grosz's sense of impotence in the face of Hitler's triumph. There were new drawings showing a grim view of things, such as *Progress* (p. 82). A monstrous figure wearing military boots and carrying a bloody whip is seen striding ahead, leaving his victim by the wayside. The album was not a success, and met with absurd criticism since German fascism was not considered the monstrous thing Grosz presented it as – in 1936, the year of the Olympics. One critic, indeed, failed to see any clear political line or committed statement. 300 copies of the album had been planned, but only a very few were in fact printed and sold.

Nude undressing, 1939

Seated Nude, 1942

Grosz's "arty" nudes were plainly not meant ironically. They were presumably intended as a sop to public taste. A French critic had detected a "soft simplicity" in some of Grosz's pictures back in 1927 – and the phrase certainly applies to these.

Resignation overcame Grosz in the US, owing mainly to his bitter realisation that all his artistic and political commitment was remaining without effect. In his autobiography there is a revealing moment when he meets Thomas Mann. Mann's wife Katja asked Grosz how long he believed Hitler could remain in power. At an earlier meeting in 1933, Thomas Mann had said the Nazis could not last longer than six months, but now Grosz replied: "'If you share your husband's view that it cannot last longer than six months, you are gravely mistaken. In my opinion it is more likely to last six years – maybe even ten, dear lady,' I added curtly. 'At any rate, longer than you and your husband imagine!'" (YN p. 267) Somewhat condescendingly, Mann replied that Grosz was still young, and that he too had had such mo-

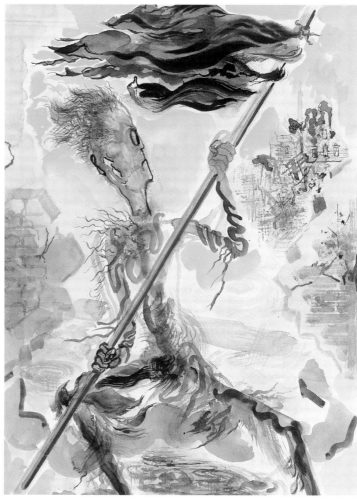

LEFT:
The Painter of Holes, uprooted, 1947/48

RIGHT:
Waving the Flag, 1947/48

The stickmen Grosz painted from 1946 on express his full resignation. Man had become a meaningless creature in a meaningless world, and even the painter, whose social impact Grosz had at one time not doubted, he now saw as producing mere holes, or nothingness.

ments as a young man; one should be optimistic. But it was Grosz, as we know to our cost, who was right.

In Germany, exhibitions of "degenerate" art began as early as 1933, culminating in the notorious Munich show of 1937. Grosz was among the artists the Nazis hated most, and 285 of his works were removed from German collections. The Munich exhibition included five of his paintings, two watercolours, and 13 graphics. In Wolfgang Willrich's unpleasant party-line pamphlet "Die Säuberung des Kunsttempels" (Purifying the Temple), the work of Grosz is referred to twenty times, more often than that of (say) Dix. In 1933 Grosz wrote to his friend and patron Felix Weil, who had supported him from the outset: "Privately I am even a little proud – at least art had some point to it."

In 1938 the Nazis stripped Grosz of his German citizenship; he became an American citizen. Like Otto Dix, he recorded his fears of war in apocalyptic pictures that drew upon inspirations from Bosch to Ensor. This period, in which he also painted nudes of little artistic interest, continued into the Second World War. Grosz became a follower of Swedenborg, who had believed that hell already existed on earth. His resignation and depression deepened.

After the war, Grosz took to painting his stickmen. As *The Painter of Holes* (p. 86) suggests, all these stickmen can produce is nothingness. Grosz wrote to Brecht in 1947: "they consist of thin but firm strokes. They cast no shadow, and are themselves completely grey. Their standard (as the Romans

The Pit, 1946
This painting was one of a number of vision-
ary works Grosz painted in the immediate
post-war period. His mother had died in one
of the last bombing raids. This picture of
death and wartime chaos and destruction he
himself felt bore a family resemblance to
Bosch's vision of hell.

ILLUSTRATION PAGE 88:
Glad to be back, 1943

ILLUSTRATION PAGE 89:
The Enemy of the Rainbow, about 1952

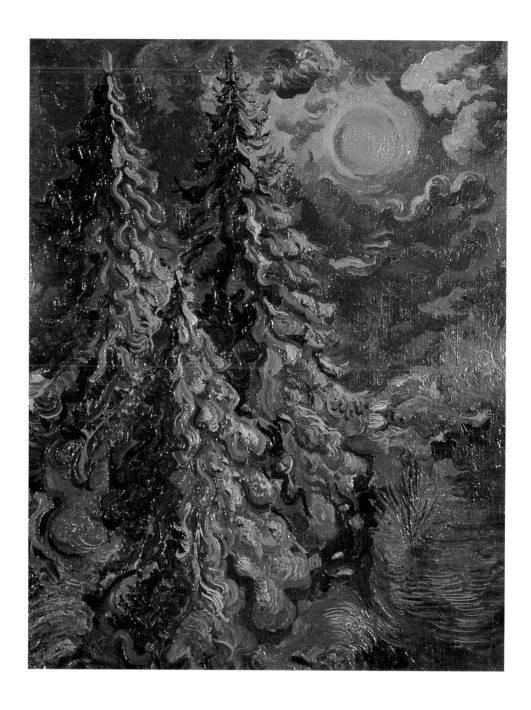

called it) is a ragged hole in a canvas. Fine. All around the painter are 100
holed attempts at paintings (he is interested – he remembers very dimly, but
he definitely does remember – in 'beauty', among other things: for instance,
he is out for the very very finest-nuanced shades of grey – because every-
thing is grey there. […] The rats – well, the moment you think of something,
a rat scurries into the corner.)" It seems fair to take this as an account of
Grosz's own frame of mind.

In 1952 a department store owner in Dallas, Texas, commissioned Grosz
to record his impressions of the people and industrial life of the city. The
watercolours that resulted recall the artist's early American period. In 1954
he visited Germany, and in 1958 was elected to the West Berlin Academy of
Fine Arts. For years he had been teaching in the US, but now at last, in
1959, he decided to return once and for all to Berlin. Grosz arrived at the
end of May; but he was to have no time to relearn the ways of his old home.
Five weeks later, in the small hours of 6 July, a woman delivering news-

Blue Pines with Red Moon, 1938

Grosz on the rubble of Berlin, 1958
26 years after emigrating, Grosz and his wife returned to Berlin, quitting an America that had disappointed them and was no longer the land of their dreams, for a country in ruins.

Grosz as Clown and Revue Girl, 1958
Grosz's last works in America were collages partly influenced by Pop Art. Here we see him as a clown with a revue dancer's body, against the New York skyline by night. The bottle in his hand lends a bitter touch to his irony.

papers discovered him in a crumpled heap in a hallway. He had been out drinking, had fallen down the stairs and suffocated.

Grosz's last works included a series of photomontages that recall his Dada days, though they also have something in common with early Pop Art. In one, Grosz appears as a *Clown and Revue Girl* (p.91), a cross between two very different kinds of people. The many sides of his personality survived to the end, not least Grosz the clown, the artist in a world that does not understand him.

George Grosz 1893–1959: A Chronology

1893 George Grosz is born on 26 July in Berlin. His name is Georg Ehrenfried Groß. His parents are Karl Ehrenfried Groß, an innkeeper, and his wife Marie Wilhelmine Luise.

1898 They move to Stolp in Pomerania.

1900 Grosz's father dies.

1901 Mother and son move to the Wedding district of Berlin.

1902 Return to Stolp. Grosz begins secondary school.

1908 Grosz returns a trainee teacher's blow and is expelled from school.

1909 Grosz begins studies at the Royal Saxon Academy of Art in Dresden, under Richard Müller, Robert Sterl, Raphael Wehle and Oskar Schindler.

1910 Publishes his first drawing in the "Ulk" supplement of the "Berliner Tageblatt".

1911 Receives the Academy diploma on 30 March.

1912 Enrols at the Berlin College of Arts and Crafts and studies there (till 1917) under Emil Orlik. Begins to paint in oils.

1913 August to November in Paris. Drawings in "Ulk", "Lustige Blätter" and elsewhere. He does his first book illustrations.

1914 Grosz volunteers on the outbreak of war.

1915 Discharged following an operation. Meets the Herzfelde brothers at Ludwig Meidner's. Publishes a first poem and drawing in Franz Pfemfert's "Aktion".

1916 Meets Theodor Däubler, who publishes an article on him in "Weiße Blätter". In protest at nationalism and patriotism he alters the form of his name to George Grosz.

1917 Called up anew, hospitalized, and again discharged after a period in a sanatorium. Grosz co-founds Berlin Dada. The "Erste George Grosz Mappe" and "Kleine Grosz Mappe" are published by Malik.

1918 Grosz joins the November group, and (with John Heartfield, Wieland Herzfelde and Erwin Piscator) the Communist party.

1919 With Wieland Herzfelde he co-founds the magazine "Die Pleite", with Franz Jung "Jedermann sein eigener Fußball", and with Carl Einstein and John Hoexter "Der blutige Ernst". Works on Max Reinhardt's "Schall und Rauch" cabaret.

1920 In April Hans Goltz mounts Grosz's first solo exhibition, in Munich. Grosz participates in the Dada show at Burchard's gallery in Berlin. In May he marries Eva Peters.

1921 His album "Gott mit uns" brings Grosz charges of defaming the Reichswehr. He is fined 300 marks. "Das Gesicht der herrschenden Klasse" is published by Malik. He visits his patron Felix Weil in Portofino.

1922 With Martin Andersen-Nexø he visits Petrograd and Moscow, where he meets Lenin. His albums "Ecce Homo", "Mit Pinsel und Schere" and "Die Räuber" are published by Malik.

1923 "Ecce Homo" is confiscated as pornography. Alfred Flechtheim becomes Grosz's dealer.

1924 In the "Ecce Homo" trial, Grosz is fined 6,000 marks for offending public morality. He becomes chairman of the "Rote Gruppe", an association of Communist artists. Up to 1927 he is a regular contributor to the Communist satirical weekly "Der Knüppel" and till 1933 to "Querschnitt", edited by Flechtheim. His album "Abrechnung folgt" is published. March till May in Paris.

1925 In France again, Grosz visits Frans Masereel and Jacques Sadoul. His album "Der Spießer-Spiegel" is published.

1926 Birth of his son Peter Michael.

George Grosz and his wife Eva with their son Peter, about 1928

1927 In France again. Begins the "Hintergrund" drawings, supplying designs for Piscator's production of "The Good Soldier Schwejk".

1928 Co-founds the "Association Revolutionärer Bildender Künstler Deutschlands" in Berlin. His drawing *Shut up and keep serving the cause* attracts a charge of blasphemy, and he is fined 2,000 marks.

1929 The verdict is reversed following an appeal.

1930 In a new trial, Grosz is finally acquitted. The albums "Das neue Gesicht der herrschenden Klasse", "Die Gezeichneten" and "Über alles die Liebe" are published. Birth of his second son, Martin Oliver.

1932 June to October teaching at the Art Students League in New York. He publishes watercolours in "The New Yorker" and "Vanity Fair".

1933 On 12 January, Grosz and his wife emigrate to the USA, where he resumes teaching with the Art Students League in New York.

1935 Visits Europe, and sees Brecht in Denmark.

1936 His anti-fascist album "Interregnum" is published by Black Sun Press, with a foreword by John Dos Passos. Its lack of success deepens Grosz's resignation. He moves to Douglaston, Long Island.

1937 He receives a two-year Guggenheim fellowship and closes his private art school. His work is exhibited in the show of "Entartete Kunst" in Munich.

1938 Grosz is stripped of his German citizenship by the Nazis, and granted American.

1939 Numerous works by Grosz are burnt by the Nazis. Wieland Herzfelde arrives in New York.

1941 Till 1942, Grosz teaches at the Columbia University School of Fine Art and the Art Students League. He begins work on his autobiography.

George Grosz in his New York studio, 1954

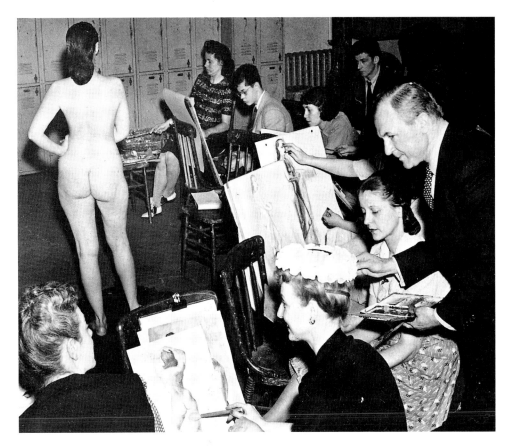

Teaching at the Art Students League, New York, about 1948

1946 The autobiography "A Little Yes and a Big No" is published. In October he has a show in New York, titled "A Piece of my World in a World Without Peace".

1947 Grosz moves to "The Cottage", Hilaire Farm, Huntington.

1948 His stickmen paintings are exhibited in New York.

1950 Grosz resumes teaching (till 1955) at the Art Students League.

1951 He visits Europe.

1953 He opens a private art school at his home.

1954 Retrospective at the Whitney Museum, New York. Grosz is elected to the American Academy of Arts and Letters. He visits Germany, where he is received by the Berlin Senate and sees Otto Dix at Lake Constance.

1955 In January Grosz returns to the USA. The German edition of his autobiography is published.

1956 Teaches at the Skowhagen School of Painting and Sculpture in Maine and lectures at the Des Moines Art Center.

1958 In West Berlin, where he is elected to the Academy of Fine Arts on 24 November. On 3 December he returns to New York.

1959 On 28 May Grosz returns to Berlin for good. On 6 July he dies in the hallway of his house at 5, Savignyplatz.

Illustrations

1
Detail from: Pastoral (*Schäferstündchen*), 1921
No. 77 in "Ecce Homo"

2
Detail from p. 52

6
George Grosz in his Berlin studio, 1921
Photo: Berlin, Ullstein Bilderdienst

7 top
Detail from p. 34 (bottom)

7 bottom
Detail from p. 91 (right)

8
Going to Work, about 1912
Auf dem Weg zur Arbeit
Watercolour and reed pen, crayon, 38.1 x 30.2cm
Princeton (NJ), Copyright Estate of George Grosz

9
Illustration for "Ulk", 1910

10
Street Fight, 1912
Straßenschlacht
Indian ink and black chalk, 25 x 37.7cm
Whereabouts unknown

11 left
Sex Murder in Ackerstraße, 1916/17
Lustmord in der Ackerstraße
Offset print, 18.6 x 19cm
Berlin, Staatliche Museen zu Berlin – Preußischer
Kulturbesitz, Kunstbibliothek

11 right
End of the Line, 1913
Das Ende des Weges
Watercolour and pencil, 27.7 x 21.7cm
Whereabouts unknown

12
Heinrich Maria Davringhausen:
The Sex Murderer, 1917
Der Lustmörder
Oil on canvas, 119.5 x 148.5cm
Munich, Bayerische Staatsgemäldesammlungen

13
John the Sex Murderer, 1918
John der Frauenmörder
Oil on canvas, 86.5 x 81cm
Hamburg, Hamburger Kunsthalle

14
The City, 1916/17
Oil on canvas, 100 x 102cm
Lugano, Thyssen-Bornemisza Collection

15
Lunatics Streetfighting, 1915
Krawall der Irren
Pen and ink, 32.1 x 22.6cm
Berlin, Staatliche Museen zu Berlin – Preußischer
Kulturbesitz, Kunstbibliothek

16
George Grosz with hat and revolver, in his studio, 1918
Photo: Princeton (NJ), Copyright Estate of George
Grosz

17 top
Texas Picture for my Friend Chingachgook, 1915/16
Texasbild für meinen Freund Chingachgook
Lithograph on cream paper, 26.9 x 27.1cm
Stuttgart, Staatsgalerie Stuttgart, Graphische Sammlung

17 bottom
Rudolf Schlichter:
Wild West, 1922/23
Watercolour, 28.9 x 35.9cm
Private collection

18 top
City traffic at Potsdamer Platz, travelling to Leipziger
Platz, about 1925
Photo: Berlin, Ullstein Bilderdienst

18 bottom
Love for Sale, Berlin, 1929
Photo: Berlin, Ullstein Bilderdienst

19
Pandemonium, 1914
Pandämonium
Indian ink, 47 x 30.5cm
Private collection

20 left
Murder, 1916
Mord
Offset print from "Ecce Homo", 1922/23

20 right
Memory of New York, 1915/16
Erinnerung an New York
Lithograph on cream paper, 37.8 x 29.6cm
Stuttgart, Staatsgalerie Stuttgart, Graphische Sammlung

21 top
Explosion, 1917
Oil on hardboard, 47.8 x 68.2cm
New York, Collection, The Museum of Modern Art.
Gift of Mr. and Mrs. Irving Moskovitz.

21 bottom
Ludwig Meidner:
The Burning City, 1913
Die brennende Stadt
Oil on canvas, 66.5 x 78.5cm
St. Louis (MO), The Saint Louis Art Museum

22 top
Suicide, 1916
Selbstmord
Oil on canvas, 100 x 77.6cm
London, Tate Gallery

22 bottom
Metropolis, 1917
Oil on card, 68 x 47.6cm
New York, Collection, The Museum of Modern Art.
Purchase.

23
Lovesick, 1916
Der Liebeskranke
Oil on canvas, 99.7 x 76.5cm
Private collection

24
Café, 1915/16
Lithograph from "Ecce Homo", 1922/23
19.5 x 13cm
Berlin, Staatliche Museen zu Berlin – Preußischer
Kulturbesitz, Kunstbibliothek

25
To Oskar Panizza, 1917/18
Widmung an Oskar Panizza
Oil on canvas, 140 x 110cm
Stuttgart, Staatsgalerie Stuttgart

26
Grey Day, 1921
Grauer Tag
Oil on canvas, 115 x 80cm
Berlin, Staatliche Museen zu Berlin – Preußischer
Kulturbesitz, Nationalgalerie

27
The German Pestilence, 1919
Die deutsche Pest
from "Die Pleite" no. 5, 1919

28 top
Blood is the best Sauce, 1919
*Die Kommunisten fallen und die Devisen steigen/
Ecrasez la famine/Blood is the best Sauce*
Pen and Indian ink, 37.5 x 55.4cm
Berlin, Staatliche Museen zu Berlin – Preußischer
Kulturbesitz, Kunstbibliothek

28 bottom
A1: The Miracle Workers, 1918
KV/Die Gesundbeter
Pen, brush and Indian ink on ivory paper,
37.7 x 34.4cm

29 top
Putsch troops with swastikas on Potsdamer Platz, 1920
Photo: Berlin, Ullstein Bilderdienst

29 bottom left
"Cheers, Noske – the proletariat has been disarmed!",
1919
"Prosit Noske! – Das Proletariat ist entwaffnet"
Pen and ink drawing for "Die Pleite" no. 3, 1919

29 bottom right
The Capitalist and Militarist wish each other a Happy
New Year, 1920
*Kapital und Militär wünschen sich: "Ein gesegnetes
neues Jahr!"*
Cover of "Die Pleite" no. 6, 1920

30 top left
Remember (*Vergeßt es nicht!*), 1931
Photolithograph from "Interregnum", 1936
29.3 x 20cm

30 top right
Rosa Luxemburg
Photo: Berlin, Landesbildstelle Berlin

30 centre
Karl Liebknecht speaking in Berlin, 1918
Photo: Berlin, Landesbildstelle Berlin

30 bottom
Spartacists in Berlin, 1919
Photo: Berlin, Landesbildstelle Berlin

31
The Victims of March are washed up, 1919
Das Wasser spült die März-Gemordeten an Land…
Photolithograph from "Gott mit uns", 1920
38.7 x 29.9cm

32
John Heartfield:
Dada 3, 1920
Der dada 3
Collage, 23.2 x 15.7cm

33
Germany: a Winter's Tale, 1917/19
Deutschland, ein Wintermärchen
Oil on canvas
Whereabouts unknown

34 top
Methusalem, 1922
Methusela
Watercolour, Indian ink and bronze paint on paper,
52.6 x 41.1cm
New York, Collection, The Museum of Modern Art.
Mr. and Mrs. Werner E. Josten Fund.

34 bottom
John Heartfield with Grosz's puppet of a "Conserva-
tive gentleman" (*Konversativer Herr*), 1919
Photo: Berlin, Akademie der Künste

35 top
Monteur Heartfield, 1920
Watercolour and adhesive on postcard, 41.9 x 30.5cm
New York, Collection, The Museum of Modern Art.
Gift of A. Conger Goodyear.

35 bottom left
The Dada Exhibition at Burchard's Gallery, 1920
Photo: Berlin, Ullstein Bilderdienst

35 bottom right
Grosz and Heartfield at the opening of the Dada Show, 1920. Photo

36
Untitled, 1920
Oil on canvas, 81 x 61 cm
Düsseldorf, Kunstsammlung Nordrhein-Westfalen

37 left
Republican Automatons, 1920
Republikanische Automaten
Watercolour on paper, 60 x 47.3 cm
New York, Collection, The Museum of Modern Art. Advisory Committee Fund.

37 right
Giorgio de Chirico:
The Prodigal Son, 1922
Il figliuol prodigo
Oil on canvas, 87 x 59 cm
Milan, Civica Galleria d'Arte Moderna

38
George and Eva Grosz in Berlin, about 1924
Photo: Princeton (NJ), Copyright Estate of George Grosz

39
Daum marries her pedantic automaton George in May 1920, John Heartfield is very glad of it, 1920
Watercolour and collage, 42 x 30.2 cm
Berlin, Galerie Nierendorf

40
Eclipse of the Sun, 1926
Sonnenfinsternis
Oil on canvas, 210 x 184 cm
Huntington, Collection of the Heckscher Museum, Huntington, New York. Museum Purchase.

41
The New Generation, 1921/22
Nachwuchs
Offset print from "Ecce Homo", 1922/23
27.8 x 18.4 cm
Berlin, Staatliche Museen zu Berlin – Preußischer Kulturbesitz, Kupferstichkabinett

42
Drawings from "Der Spießer-Spiegel", Dresden 1925, second edition 1932

43
People, 1919
Menschen
Watercolour, pen and Indian ink, 42 x 30.2 cm
Private collection

44 top
Wieland Herzfelde, Eva and George Grosz, Rudolf Schlichter, John Heartfield, 1921. Photo

44 bottom
George Grosz in his studio, 1920
Photo: Princeton (NJ), Copyright Estate of George Grosz

45
Five in the Morning!, 1920/21
Früh um 5 Uhr!
Photolithograph, 37.8 x 27.5 cm
Berlin, Staatliche Museen zu Berlin – Preußischer Kulturbesitz, Kunstbibliothek

46
Orgy, 1920
Orgie
Watercolour, pen and Indian ink on paper
Berlin, Galerie Pels-Leusden

47
Dusk, 1922

Dämmerung
Watercolour from "Ecce Homo", 1922/23
Berlin, Staatliche Museen zu Berlin – Preußischer Kulturbesitz, Kunstbibliothek

48
Sauve qui peut!, 1922
Schwimme, wer schwimmen kann, und wer zu plump ist, geh' unter!
Lithograph from "Die Räuber", 1922

49 top
August Sander:
Unemployed, 1928
Arbeitslos
Photograph from "Antlitz der Zeit", 1929
Cologne, August Sander Archiv

49 bottom left
Berlin, Kreuzberg district, about 1930
Photo

49 bottom right
She's just a char, 1924
Sie macht nur sauber
Pencil, 59.1 x 47.5 cm

50
A Man of Conviction, 1928
Ein Mann von Überzeugung
Watercolour and Indian ink on paper, 66 x 48 cm
Washington (DC), Hirshhorn Museum and Sculpture Garden, Smithsonian Institution, Gift of Joseph H. Hirshhorn, 1966

51
The Best Years of their Lives, about 1923
In den besten Jahren
Watercolour, 62.6 x 49.5 cm
Hanover, Kunstmuseum Hannover

52
The Agitator, 1928
Der Agitator
Oil on canvas, 108 x 81 cm
Amsterdam, Stedelijk Museum

53
Grosz with "The Agitator" (*Der Agitator*), 1928
Photo: Berlin, Ullstein Bilderdienst

54 top
Otto Griebel:
The Naked Whore, 1923
Die nackte Nutte
Pencil and watercolour on paper, 40.6 x 29.1 cm
Milwaukee (WI), Marvin and Janet Fishman Collection

54 bottom left
Otto Dix:
Brothel Madame, about 1923
Puffmutter
Watercolour, 50 x 35 cm
Vaduz, Otto Dix Foundation

54 right
Streetwalking, 1922
Promenade
Offset print, 20 x 21.6 cm
Berlin, Staatliche Museen zu Berlin – Preußischer Kulturbesitz, Kunstbibliothek

55
Strength and Grace, 1922
Kraft und Anmut
Watercolour, pen and Indian ink, 53.3 x 44 cm
Cologne, Museum Ludwig

56 top left
Grosz, Wieland Herzfelde and defence counsel Apfel at the blasphemy trial, 1929
Photo: Berlin, Akademie der Künste

56 bottom right
Cover of "Ecce Homo", 1922
Offset

56 bottom left
Serenade, 1922
Ständchen
Offset print from "Ecce Homo", 1922/23

57
Cross-section, 1919/20
Querschnitt
Offset print from "Ecce Homo", 1922/23
24.2 x 19.1 cm
Berlin, Staatliche Museen zu Berlin – Preußischer Kulturbesitz, Kunstbibliothek

58 left
Ecce Homo, 1921
Watercolour from "Ecce Homo", 1922/23
Berlin, Staatliche Museen zu Berlin – Preußischer Kulturbesitz, Kunstbibliothek

58 right
Passers-by, 1921
Passanten
Watercolour from "Ecce Homo", 1922/23
Berlin, Staatliche Museen zu Berlin – Preußischer Kulturbesitz, Kunstbibliothek

59 left
Before Sunrise, 1922
Vor Sonnenaufgang
Watercolour from "Ecce Homo", 1922/23
Berlin, Staatliche Museen zu Berlin – Preußischer Kulturbesitz, Kunstbibliothek

59 right
Ah crazy world, you wonderful freakshow, 1916
Ach knallige Welt, du seliges Abnormitätenkabinett
Watercolour from "Ecce Homo", 1922/23
Berlin, Staatliche Museen zu Berlin – Preußischer Kulturbesitz, Kupferstichkabinett

60
The White Slaver, 1918
Der Mädchenhändler
Watercolour, reed pen and Indian ink on card, 31.7 x 23.8 cm
Darmstadt, Hessisches Landesmuseum

61
Beauty, thee will I praise, 1919
Schönheit, dich will ich preisen!
Watercolour, pen and Indian ink, 42 x 30.2 cm
Berlin, Galerie Nierendorf

62
How to get rich, 1923
Wie werde ich...... reich?
Two-page spread of 12 illustrations from "Die Pleite", 1923

63
Soirée, 1922
Watercolour from "Ecce Homo", 1922/23
Berlin, Staatliche Museen zu Berlin – Preußischer Kulturbesitz, Kunstbibliothek

64 left
Rudolf Schlichter:
A Meeting of Fetishists and Manic Flagellants, about 1923
Zusammenkunft von Fetischisten und manischen Flagellanten
Watercolour, 43.5 x 27 cm
Private collection

64 right
Rudi S., 1921
Offset print from "Ecce Homo", 1922/23
27.8 x 20.3 cm
Berlin, Staatliche Museen zu Berlin – Preußischer Kulturbesitz, Kunstbibliothek

65
Artist and Model, 1928
Künstler und Modell
Oil on canvas, 115.6 x 75.6 cm
New York, Collection, The Museum of Modern Art. Gift of Mr. and Mrs. Leo Lionni.

66 top
Grosz with his model for "Max Schmeling", 1926
Photo: Berlin, Bildarchiv Preußischer Kultur-
besitz

66 bottom
Bertolt Brecht and boxer Samson-Körner, 1928
Photo: Berlin, Ullstein Bilderdienst

67
Max Schmeling the Boxer, 1926
Porträt Max Schmeling
Oil on canvas, 109 x 79cm
Berlin, Axel Springer Verlag AG

68
Portrait of the Writer Walter Mehring, 1925
Porträt des Schriftstellers Walter Mehring
Oil on canvas, 90 x 80cm
Antwerp, Koninklijk Museum voor Schone
Kunsten

69 top
Portrait of Dr. Eduard Plietzsch, 1928
Porträt des Dr. Eduard Plietzsch
Oil on canvas, 110 x 79cm
Cologne, Museum Ludwig

69 bottom
Portrait of the Writer Max Herrmann-Neisse, 1925
*Porträt des Schriftstellers Max Herrmann-
Neisse*
Oil on canvas, 100 x 101cm
Mannheim, Städtische Kunsthalle

70
Grosz at the Café de la Plage, Boulogne-sur-Mer,
about 1927
Photo: Berlin, Ullstein Bilderdienst

71
Pointe Rouge Landscape near Marseilles, 1927
Landschaft Pointe Rouge bei Marseille
Oil on canvas, 54 x 72cm
Princeton, (NJ), Copyright Estate of George
Grosz

72 top
Shut up and keep serving the cause, 1927
Maul halten und weiter dienen
Gravure print from "Hintergrund", 1928
15.2 x 18.1cm

72 bottom
Grosz with "The Pillars of Society" (*Die Stützen der
Gesellschaft*), 1926
Photo: Princeton (NJ), Copyright Estate of George
Grosz

73
The Pillars of Society, 1926
Die Stützen der Gesellschaft
Oil on canvas, 200 x 108cm
Berlin, Staatliche Museen zu Berlin – Preußischer
Kulturbesitz, Nationalgalerie

74 top
Hitler the Saviour, 1923
Hitler der Retter
from "Die Pleite" no. 8, 1923

74 centre
The Tree of Life, Phases 2 and 3, 1927
Der Lebensbaum, Phase 2 und 3
Gravure print from "Hintergrund", 1928
Berlin, Staatliche Museen zu Berlin – Preußischer
Kulturbesitz

74 bottom
Why?, 1928
Wofür?
Gravure print from "Hintergrund", 1928

75
Self-Portrait, Warning, 1927
Selbstportrait als Warner
Oil on canvas, 98 x 79cm
Berlin, Galerie Nierendorf

76
Manhattan, about 1934
Watercolour, 42 x 57cm
Princeton, (NJ), Copyright Estate of George Grosz

77
Mouse in the Trap, 1955
Maus in der Falle
Drawing, 23.5 x 15.2cm
Cambridge (MA), Courtesy of the Fogg Art Museum,
Harvard University Art Museums, Anonymous gift in
gratitude for the friendship and kindness of Dean
Wilbur, Joseph Bender

78 left
Drawing from the American Sketchbook, 1932
Berlin, Akademie der Künste

78 right
New York Street, 1932
Straße, New York
Reed pen and Indian ink, 56 x 43.4cm
Princeton (NJ), Copyright Estate of George Grosz

79
New York Skyline, 1951
Oil, 25 x 34cm
Princeton (NJ), Copyright Estate of George Grosz

80 top
President von Hindenburg and Chancellor Hitler, 1933
Photo: Berlin, Ullstein Bilderdienst

80 centre
Torchlit SA procession to Hitler's Chancellery, 1933
Photo: Berlin, Ullstein Bilderdienst

80 bottom
SA guard with captives, 1933
Photo: Berlin, Ullstein Bilderdienst

81
A Writer, eh?, 1935
Schriftsteller, was?
Drawing from "Interregnum", 1936

82
Progress, 1935/36
Pen and ink, 27.5 x 21.6cm
Princeton (NJ), Copyright Estate of George Grosz

83
Cain, or, Hitler in Hell, 1944
Kain oder Hitler in der Hölle
Oil on canvas, 99 x 124.5cm
Private collection

84 top
Nude, 1938
Akt
Oil on canvas, 40.5 x 50.5cm
The Hague, Collection P.B. van Voorst van Beest

84 bottom
Nude undressing, 1939
Sich entkleidender Akt
Charcoal drawing, 58.5 x 40cm
The Hague, Collection P.B. van Voorst van Beest

85
Seated Nude, 1942
Sitzender Akt
Oil on paper, 58.3 x 39.7cm
The Hague, Collection P.B. van Voorst van Beest

86 left
The Painter of Holes, uprooted, 1947/48
Der Maler des Lochs, entwurzelt
Watercolour, 89.5 x 63.2cm
Cambridge (MA), Courtesy of the Busch-Reisinger
Museum, Harvard University Art Museums,
Association Fund

86 right
Waving the Flag, 1947/48
Mit schwenkender Fahne
Watercolour on paper, 63.5 x 45.7cm
New York, Whitney Museum of American Art.
Purchase and Exchange

87
The Pit, 1946
Die Grube
Oil on canvas, 153 x 94.6cm
Wichita, The Roland P. Murdock Collection,
Wichita Art Museum, Wichita, Kansas

88
Glad to be back, 1943
Ich bin froh, wieder da zu sein
Oil on chipboard, 71.1 x 50.7cm
Tempe (AZ), The Olive B. James Collection of Ameri-
can Art, Arizona State University

89
The Enemy of the Rainbow, about 1952
Der Feind des Regenbogens
Watercolour, 43 x 63cm
Princeton (NJ), Copyright Estate of George Grosz

90
Blue Pines with Red Moon, 1938
Blaue Pinien mit rotem Mond
Oil, 41 x 50cm
Princeton (NJ), Copyright Estate of George Grosz

91 left
Grosz on the rubble of Berlin, 1958
Photo: Berlin, Akademie der Künste

91 right
Grosz as Clown and Revue Girl, 1958
Grosz als Clown und Varietégirl
Collage, 30.5 x 27cm

92
George Grosz and his wife Eva with their son Peter,
about 1928
Photo: Berlin, Akademie der Künste

93 top
Teaching at the Art Students League, New York,
about 1948
Photo: Berlin, Bildarchiv Preußischer Kulturbesitz

93 bottom
George Grosz in his New York studio, 1954
Photo: Berlin, Akademie der Künste

The publisher wishes to thank the museums, galleries
and collectors who have helped make this book
possible. Our special gratitude goes to Peter Grosz, the
son of the artist, for his kind cooperation and friendly
assistance.
In addition to the persons and institutions named in our
picture credits, we also wish to mention the following
archive sources and photographers for making material
available to us: Jörg P. Anders, Berlin: front cover, 73;
Estate of George Grosz, Princeton (NJ): 33; Michael
Hasenclever Gallery, Munich: 17; Kranichphoto, Ber-
lin: 34, 56, 88; Henry Nelson, Wichita: 87; Rheinisches
Bildarchiv, Cologne: 55, 69; Sandak, Inc./G.K. Hall,
Boston: 86; Foto Saporetti, Milan: 37; Elke Walford,
Hamburg: 10, 11, 13, 19